S0-AJV-061

New Heights
in *Lace Knitting*

17 Lace Knit Accessory Patterns

Andrea Jurgrau

INTERWEAVE.
interweave.com

CONTENTS

© iStockphoto.com/mmac72

INTRODUCTION

The lore of the seven summits calls to every mountaineer. Documented in the 1988 book of the same name by Richard (Dick) Bass, the seven summits refer to the tallest mountain on each of the seven continents. Of course, the list is not without controversy, both nationalistic and political.

I consider myself an armchair mountain climber. I like to hike and climb, but I am "fair weather." A hike on a lovely day is just my cup of tea. Put a heavy pack on my back and with a little sunshine you can drag me up a modest mountain. Toss in some rain and I am not smiling. Add some snow, ice, and a bit of high altitude . . . well, let's just say I can meet you at the bar when you get back and hear all your war stories!

Summiting a mountain always begins with a few simple steps. And as it is with climbing, so it is with knitting. Basic knit, purl, and yarnover stitches can come together to make lace that is simple but elegant; and, for those seeking further adventures, these very same stitches can unfold into spectacular designs.

So I think of this book as a knitter's approach to the seven summits. It is proverbial mountain climbing for lace knitters who are adventurous; delighted by the basics, yet yearning for more.

This collection includes seven significant projects, each inspired by one of the major summits. Throw in a few slightly less complex projects as homage to the controversial peaks, then add a few treks to train for the big climbs, and you have a cross-globe mountaineering tour for lace knitters. I'll bring the yarn and you bring the ropes. See you in Kathmandu.

All the mountain heights listed were accurate at the time I designed these pieces, but glaciers melt and shift and earthquakes happen. The earth is always changing, so consider them approximate!

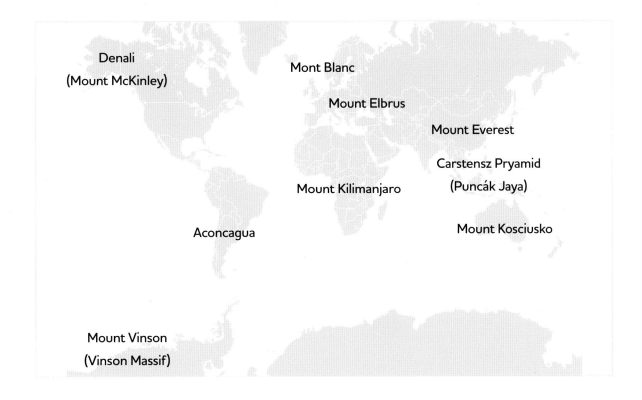

Denali
(Mount McKinley)

Mont Blanc

Mount Elbrus

Mount Everest

Carstensz Pryamid
(Puncák Jaya)

Mount Kilimanjaro

Mount Kosciusko

Aconcagua

Mount Vinson
(Vinson Massif)

Chapter 1

MATERIALS

For me, knitting is a process. It's as much about the creating as it is about the finished product. With that in mind, selecting materials isn't just about the end result; it's about the pleasure gotten from the knitting itself. Along with choosing materials appropriate for the end product, choose materials that you'll find pleasurable to work with. Take care in choosing the yarn and beads for each project and you'll find enjoyment from cast-on to bind-off!

© iStockphoto.com/earleliason

YARN

There are lots of yarns on the market that are ideal for lace knitting. Many are available from small yarn companies and independent dyers—you'll find a selection listed in the Sources for Supplies on page 138. I delight in using unique yarns whenever I can. The trick in lace knitting is to find the right combination of yarn and pattern. Choosing just the right yarn for a lace project is a large part of the fun. Lace yarns are available in a huge range of colors, dye techniques, weights, fiber content, and construction, and you'll want to consider all the elements when making a choice. Each characteristic will contribute to a unique process and end result.

The beauty of knitting lace accessories is that yarn substitutions are relatively easy. Most yarns of similar weight and fiber content will behave the same as those shown in the projects. Of course, it's always a good idea to knit a generous swatch and block it to make sure that the yarn you've chosen will work well with the pattern. Because most of the projects in this book require less than 800 yards (732 m), they provide the opportunity for you to experiment with yarn and color choices without too big an investment in money or time.

COLOR

When choosing a color, consider both the process and the finished object. I always choose colors that I'll enjoy working with as well as wearing. In general, light colors are easier to see as you knit and they show off lace patterns well; solid colors show off lace patterns better than semisolids and tone-on-tone yarns, but these can produce nice effects when used judicially.

For the most part, I follow the rule that if the stitch pattern is complicated, the yarn shouldn't be. However, if the values or tones of the colors are very close, as in the handspun version of Indiecita on page 106, variegated yarns can add pleasing visual dimension. If the colors in the yarn are quite different in tone or the values are very different, the yarn may dominate to the point of obscuring the lace pattern.

Tone-on-tone colors can work well, as long as the contrast between the shades isn't distracting. For the Malabrigo Lace version of Indiecita on page 106, I chose a yarn that has significant color variation, but all the colors are closely related in tone. Because the lace motif is bold, it isn't overpowered by the variegation in the yarn.

Yarns that have long color repeats—the longer the repeat, the better—also can be very nice, but be sure to knit a swatch to be sure you like the effect. Gradient yarns (those that progress from one color to another through the entire skein) such as the yarn used for African Violet on page 92, are lovely for lace, as are long color repeat yarns such as the yarn used for the Prayer Flag Scarf on page 42.

WEIGHT

Keep in mind that "laceweight" is a rather generic term that encompasses a wide range of thicknesses. The American Craft Yarn Council (CYC) designates any yarn lighter than fingering weight to be laceweight, which they designate as "#0 Lace." This category includes yarns at 600 yards (549 m)/100 grams to yarns at 1,700 yards (1,554 m)/100 grams and right down to sewing thread. When choosing a laceweight yarn, pay attention to how many yards are in 100 grams. If you haven't worked with very fine yarn before, I suggest you begin with one of the heavier yarns in the category, and progress from there. See the box below for a general range in yardages for laceweight yarns.

Typical Yardages for Laceweight Yarns Per 100 Grams	
Heavy	600–800 yards (549–732 m)
Average	800–1,100 yards (732–1,006 m)
Fine	1,100–1,700 yards (1,006–1,554 m)
Cobweb	1,700+ yards (1,554+ m)

FIBER CHARACTERISTICS

Laceweight yarns come in a wide range of fiber types. When making a choice, consider the preferences of both you as the knitter and the eventual wearer. For example, if you'll be knitting during warm weather, you might want to consider a cooler fiber, such as cotton or linen. If, on the other hand, you'll be knitting during the cold winter months, you might prefer to work with a warm fiber, such as merino, alpaca, cashmere, or kid mohair, that will be comfortable in your lap when the temperatures drop.

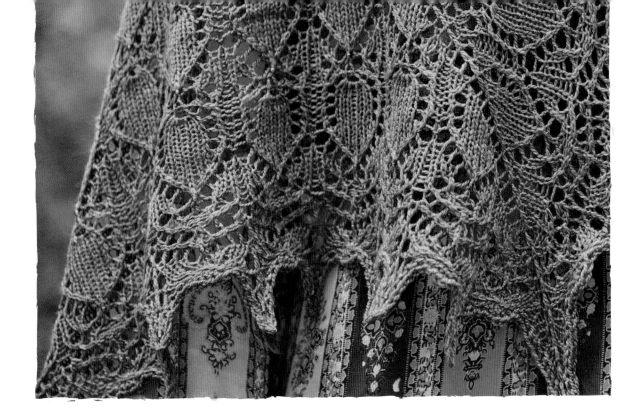

Memory is the ability of a fiber to spring back to its original shape after being stretched or blocked. In general, wool has the best memory of all fibers. Cotton and linen lack memory.

Drape is related to memory, in that fibers without memory often have better drape (or flow). Fibers with the best drape include cotton, silk, and linen. Silk is often combined with animal fibers to instill better drape.

Warmth is the ability of a particular fiber to retain heat or insulate. A fluffy yarn (spun in such a way that air is trapped in it) provides more insulation than a tightly spun yarn and is therefore warmer. Merino, alpaca, cashmere, and kid mohair are all considered "warm" fibers. Silk can be both warm and cool.

Coolness is the opposite of warmth. Cooler fibers do not trap air or retain heat and, therefore, provide less insulation. Cotton, linen, and silk are considered "cool" fibers.

Halo is the fluffiness that some fibers either begin with or develop after blocking. Kid mohair, which has a very long staple length, has a lovely halo. Alpaca and cashmere also exhibit a halo, but to a lesser degree. The way a yarn is spun will contribute to the halo in the finished yarn.

Crispness is related to a lack of elasticity. Crisp yarns tend to provide excellent stitch definition and are typically cool to the touch. Linen is the classic example of a crisp yarn.

Softness is related to the diameter of the individual fibers. Fibers that are very fine are generally softer than coarser fibers. The finest (and softest) animal fibers are qiviut, cashmere, baby alpaca and other camelids, and very fine wools (usually merino). The way a yarn is spun can also impact the softness of a particular yarn.

In general, natural fibers, which can be blocked to reveal the full beauty of lace patterns, are preferable to synthetics, which generally can't. I've used only natural fibers for the projects in this book, and the blocking directions assume that natural fibers have been used.

YARN CONSTRUCTION

Most knitters don't give much, if any, thought to how a yarn is constructed when selecting yarn for a project. But yarn construction can have a significant effect in the longevity of the finished piece. For example, a baby blanket will be subjected to a lot of wear and have to withstand many washings, whereas a wedding shawl will undergo minimal handling. A yarn with multiple plies will be sturdier and less likely to show wear than a singles. Fibers with long staple lengths (the length of individual fibers), such as some wools, silk, and kid mohair, are less likely to pill than those with short staple length, such as cotton and cashmere. In addition, yarns that are more tightly spun will be less likely to pill than those that are loosely spun.

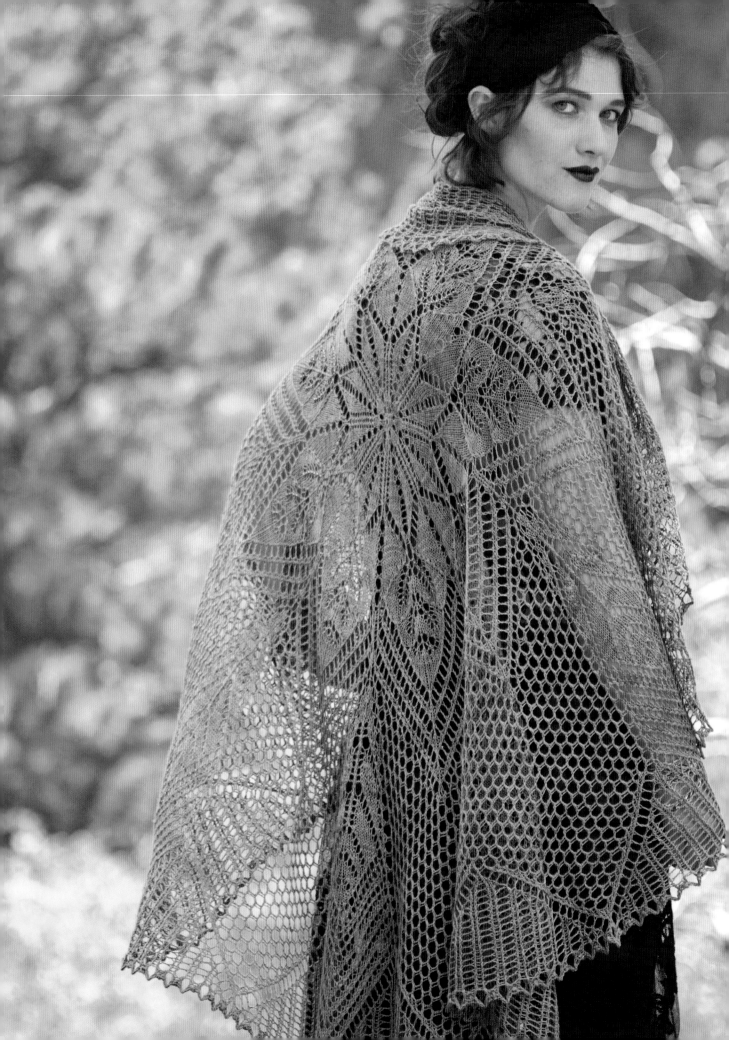

BEADS

In general, I include beads to add a little elegance to my projects. However, I use beads in moderation and I typically avoid sharp contrast between the yarn and beads. In some cases, you might not even notice the beads on first glance. But once noticed, you'll appreciate the extra je ne sais quoi that they contribute. Beads also add some weight, which adds to the overall drape. It's perfectly fine to omit the beads, but before you decide that they're not for you, at least give them a try!

Beads come in a myriad of colors and finishes that will match every yarn. Take your yarn with you when you shop for beads so you're sure to choose just the right color. When selecting beads, don't skimp on quality. Quality beads are more uniform both in outer circumference and hole size, which tends to be larger—and therefore easier to work with—than inexpensive beads. Look for beads that have permanent finishes—beads that are simply dyed can fade or bleed onto the yarn when wet and should be avoided. If you're unsure about the colorfastness, use the bead in a knitted swatch, then wash it. I enjoy using all sorts of beads, but I tend to favor Japanese seed beads for their uniform quality.

The bead sizes specified for the projects in this book are based on the specified yarn. If you decide to substitute a different yarn, be sure to check that bead size doesn't have to change accordingly. In general, an 8/0 bead works for heavy and average laceweight yarn; a 10/0 (or even 12/0) works for finer laceweights. If you decide to use a different size bead, you'll also need to adjust the number of grams needed—there are fewer 6/0 beads than 8/0 beads in a gram!

Beads come in a variety of shapes—round (called seed beads), square, hexagonal, and triangular—all of which reflect the light differently. It's always best to swatch a few before deciding which is best for your project.

NEEDLES & CROCHET HOOKS

The tools you select are critical to the ease and success of your knitting. There are many types of needles available, and most knitters have their favorites. But when it comes to lace knitting, I recommend tapered, pointy tips and, for circular needles, very smooth joins and flexible, smooth cables.

If your project includes beads, you'll need a small, steel crochet hook or a beading wire. Whichever you prefer, the hook or wire must be small enough to fit through your bead, grab your yarn, and then bring the yarn through the bead easily. You can damage your yarn if you do not use the correct size hook or bead for the yarn. The best way to be sure you have the correct hook is to try it with your yarn and bead. Keep in mind that while hook sizes are inconsistent from manufacturer to manufacturer, the sizes reported in millimeters are most reliable. I've found that a 0.6–0.75 mm steel hook works well for size 8/0 beads and average laceweight yarn.

BLOCKING WIRES & PINS

I use blocking wires for all my lace pieces. Wires come in lengths ranging from 12" (30.5 cm) to 60" (152.5 cm) and they can be rigid or flexible. I specify the type I used for each project. But keep in mind that there's always more than one way to block something.

Of the many types of blocking pins, I prefer stainless steel T-pins that don't run the risk of developing rust, which can stain yarn. Be sure to use pins with smooth tips. As they get older, burrs can develop on the tips that can snag the yarn. Such pins should be replaced.

Blocking mats come in a variety of sizes. I usually use 24" (61 cm) interlocking squares originally intended as gym flooring.

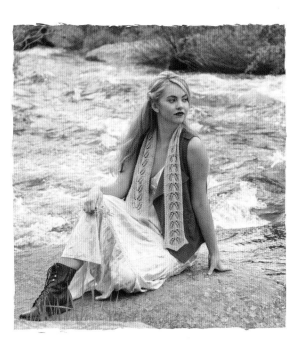

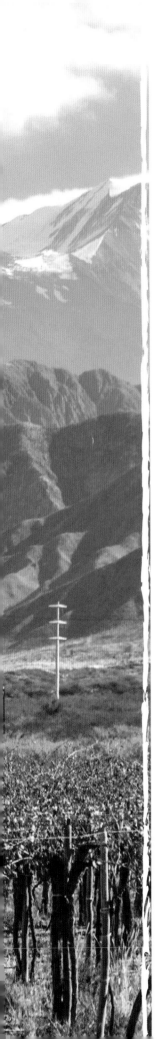

Chapter 2

TECHNIQUES

The following techniques are essential for the successful outcome of the projects in this book. The techniques covered are those I prefer, but experienced knitters can feel free to modify techniques according to their own preferences. There is always more than one path up a mountain!

© iStockphoto.com/Kseniya Ragozina

PLACING BEADS

This method allows precise placement of the bead in an individual stitch and is the method used for most of the projects in this book. Although it's easier to put the bead on the stitch before it is worked, doing so can compromise the tension on that stitch.

Work to the stitch designated for bead placement, work the stitch as specified in the instructions, slip a bead onto the shaft of a crochet hook, remove the knitted stitch from the knitting needle by lifting the stitch just worked with the hook **(Figure 1)**. Slide the bead onto the stitch just worked, return that stitch to the left needle, adjust the tension, then slip that stitch onto the right knitting needle **(Figure 2)**.

FIGURE 1

FIGURE 2

I-CORD

With a double-pointed needle, cast on the desired number of stitches. *Without turning the needle, slide the stitches to the other end of the needle, pull the yarn around the back, and knit the stitches as usual; repeat from * for desired length.

WORKING WITH HAND-DYED YARNS

Because each skein of a hand-dyed yarn is unique, any project that uses more than one skein runs the risk of having a visible line where you change skeins. This is not a defect in the yarn, but simply the nature of hand-dyed yarns. You can simply accept that and embrace the color change. That works sometimes for a piece worked in the round, such as a square or a circle. And it also can work for a top-down triangle such as the Mount Elbrus project on page 86. But if you want to avoid a visible color shift, you can simply "feather" the second skein in, by alternating rows from the first skein and then the second. I only do this for 5–10 rows when I switch skeins (more if the two skeins are less alike). You can alternate for the entire project, but that never appeals to me.

BIND-OFFS

Three-Needle Bind-Off

Place stitches to be joined onto two separate needles. Hold them with right sides of knitting facing together. Insert a third needle into the first stitch on each of the other two needles and knit them together as one stitch. *Knit next stitch on each needle the same way. Pass first stitch over second stitch. Repeat from * until one stitch remains on third needle. Cut yarn and pull tail through last stitch.

A loose bind-off is critical for the proper blocking of lace. The following methods will provide a sufficiently loose edge. The project instructions will specify which type to use.

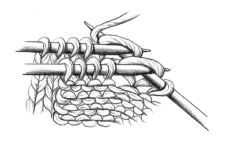

Gathered Crochet Bind-Off

See page 18 for crochet instructions.

Insert hook through the back legs of specified number of stitches **(Figure 1; three stitches shown)** to gather them, pull a loop through **(Figure 2)** so there is one loop on hook, work a crochet chain the specified length **(Figure 3; eight stitches shown)**, *insert crochet hook through the back legs of the next group of stitches **(Figure 4)**, pull the yarn loop through these stitches as well as through the stitch of the chain **(Figure 5)**, work a crochet chain for the specified number of stitches; repeat from *.

If working in rounds, finish by joining the final chain to the base of the first gathered group, then pull the yarn through the final loop leaving a 9" (23 cm) tail.

If working in rows, finish by pulling the loop through the final group of stitches, then pull the yarn through the final loop leaving a 9" (23 cm) tail.

Lace Bind-Off

This smooth and stretchy method is ideal for edges that will be stretched during blocking. Be sure to work loosely but evenly; use a needle one or two sizes larger than you knit with if desired.

Slip 1 stitch, knit 1 stitch, *insert the left needle tip into the front of both of these stitches and knit them together through the back legs **(Figure 1)**, return resulting stitch to the left needle tip; repeat from * until all stitches have been worked and one stitch remains on right needle. Cut yarn leaving a 5" (12.5 cm) tail, bring tail through remaining stitch and pull tight to secure.

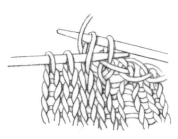

FIGURE 1

CAST-ONS

Several of the pieces in this book are worked outward from the center and require Circular cast-ons:

Emily Ocker's Circular Cast-On

I learned this method from *Elizabeth Zimmerman's Knitter's Almanac* (Dover Publications, 1981).

Make a simple loop of yarn with the short end hanging down. With a crochet hook, *draw a loop through the main loop, then draw another loop through this loop. Repeat from * for each stitch to be cast on. Divide the stitches evenly on four double-pointed needles.

After several inches of the pattern have been worked, pull on the short end to tighten the loop and close the circle.

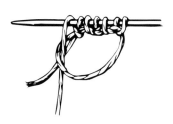

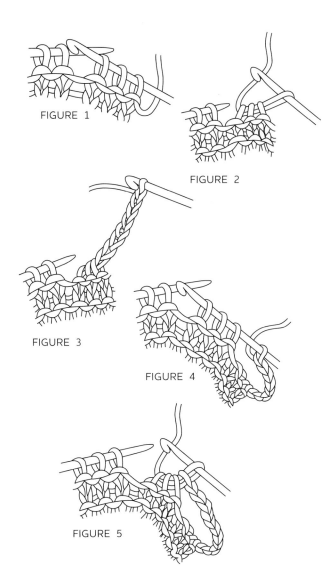

FIGURE 1

FIGURE 2

FIGURE 3

FIGURE 4

FIGURE 5

Marianne Kinzel's Circular Method

This method comes from Marianne Kinzel's *First Book of Modern Lace Knitting* (Dover Publications, 1972). It's especially good when using fine yarn.

You'll need a set of five double-pointed needles in the size needed for the specified gauge and a crochet hook that's close to the same size as the knitting needles. See page 18 for crochet instructions.

With the crochet hook, make a crochet chain the specified number of stitches long **(Figure 1; eight stitches shown)**, then use a slip stitch to join the chain into a loop **(Figure 2)**. Work a single crochet into each of the next three chain stitches (four stitches on the crochet hook), divide these four stitches evenly on two double-pointed needles, work a single crochet into each of the next four chain stitches **(again four stitches on crochet hook; Figure 3)**, then divide these four stitches evenly on two other double-pointed needles **(Figure 4)**.

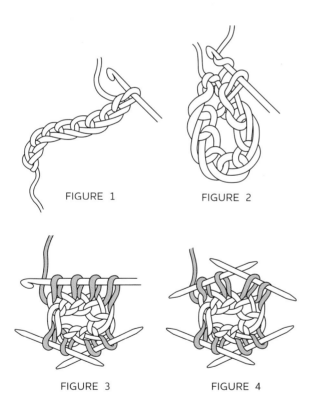

FIGURE 1 FIGURE 2

FIGURE 3 FIGURE 4

Many of the pieces in this book begin with a provisional cast-on. This allows for an elastic edge and seamless pick-up of new stitches:

Invisible Provisional Cast-On

Make a loose slipknot of working yarn and place it on the right needle tip. Hold a length of contrasting waste yarn (of about the same diameter as the working yarn) next to the slipknot and around your left thumb; hold the working yarn over your left index finger. *Bring the right needle forward under the waste yarn, over the working yarn, grab a loop of working yarn **(Figure 1)**, then bring the needle back behind the working yarn and grab a second loop **(Figure 2)**. Repeat from * for the desired number of stitches. When you're ready to work in the opposite direction, carefully pull out the waste yarn as you place the exposed loops onto a knitting needle.

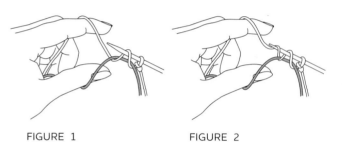

FIGURE 1 FIGURE 2

Because lace needs blocking to really show its beauty, you need a nice stretchy cast-on. Stretchy cast-ons:

Knitted Cast-On

Make a slipknot of working yarn and place it on the left needle tip. *Insert the right needle tip knitwise into the slipknot, wrap the yarn around the needle as if to knit, and pull the loop through **(Figure 1)**. Keeping the slipknot on the left needle tip, place the new loop onto the left needle in front of it to form a new stitch **(Figure 2)**. Repeat from *, always working into the last stitch made (only work into the slipknot for the first stitch).

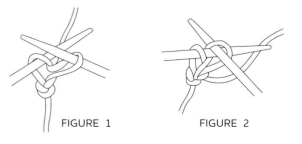

FIGURE 1 FIGURE 2

Long-Tail Cast-On

To ensure that this cast-on is suitably stretchy, I work this method over two needles of the size needed to get gauge.

Leaving a long tail (about ¼" [6 mm] per stitch), make a slipknot and place it on the right needle tip. Place the thumb and index finger of your left hand between the yarn ends so that the working yarn is around your thumb. Secure both yarn ends with your other fingers. Hold your palm upward, making a V of yarn **(Figure 1)**. *Bring the needle up through the loop around your thumb **(Figure 2)**, catch the first strand around your index finger, and bring the needle back down through the loop on your thumb **(Figure 3)**. Drop the loop off your thumb and place your thumb back in the V configuration while tightening the resulting stitch on the needle **(Figure 4)**. Repeat from * for the desired number of stitches.

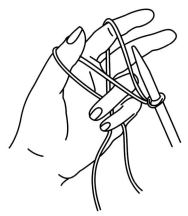

FIGURE 1

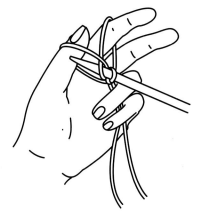

FIGURE 3

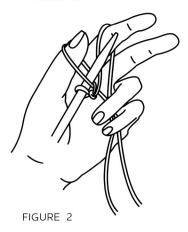

FIGURE 2

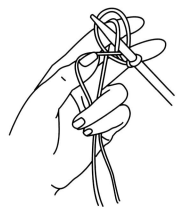

FIGURE 4

BLOCKING

Blocking may be the most critical step in a lace project. Just off the needles, a lace project can look like a worn-out rag. Only through blocking will its full beauty be revealed. I always wet-block my lace by soaking it in cool water for at least 30 minutes (perhaps longer for silk) so that the fibers are thoroughly wet, pressing the project down into the water a few times as it soaks to ensure uniform water penetration. If desired, you can add a mild soap to gently wash the piece at this time, but be careful to rinse it well to remove the soap.

Press out the excess water with your hands and then roll the piece in a thick towel to remove the extra water. Lay it on a flat padded surface and use wires and T-pins to block as directed in the pattern. Allow it to air-dry completely before removing the blocking wires and pins. I generally weave in the loose ends before I block a piece, but I don't trim the remaining tails until after it has completely dried.

It's important to note that the dimensions of the knitting right off the needles will be considerably smaller than after the piece has been stretched during blocking. It's equally important to note that the blocked dimensions are the maximum dimensions the piece will measure—most will relax a little with handling.

READING CHARTS

If you're new to reading charts, don't be intimidated. Charts represent the knitted fabric in a very logical way. Each symbol is designed to represent how the stitches will appear (when viewed from the right side) after they've been worked. For example, a right-leaning decrease is represented by a right-leaning symbol on the chart; a yarnover, which forms an open eyelet, is represented by an open circle on the chart. Charts will help you learn to read your knitting, and as you get better at reading your knitting, charts will become easier. As you gain experience with both, you'll learn to recognize mistakes and fix them quickly. Start with the simpler projects and practice comparing what's on your needles with what's shown in the chart. The sidebar below gives general rules for working with charts.

To help keep your place on a chart, it's a good idea to mark the row being worked. For charts in which there are no row repeats, my favorite technique is to make a photocopy of the chart and use a highlighter to color each row

as I complete it. Not only does this mark my place, but it also allows me to compare the row I'm working on with those I've already completed. If the chart involves a series of rows that are repeated (outlined in red), the highlighter method only works for the first repeat. In these cases, I fix removable highlighter tape to the row being worked, and I move the tape up the chart as I progress from row to row. This allows me to start afresh with the first row of each repeat.

CROCHET

Crochet Chain (ch)
*Yarn over hook and draw through a loop on hook. Repeat from * for the desired number of stitches.

Single Crochet (sc)
*Insert hook into the next stitch, yarn over hook and draw through a loop, yarn over hook **(Figure 1)**, and draw it through both loops on hook **(Figure 2)**. Repeat from * for the desired number of stitches.

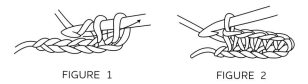

FIGURE 1 FIGURE 2

Slip Stitch Crochet (sl st) (B)
*Insert hook into stitch, yarn over hook and draw a loop through both the stitch and loop already on the hook. Repeat from * for the desired number of stitches.

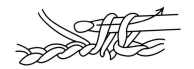

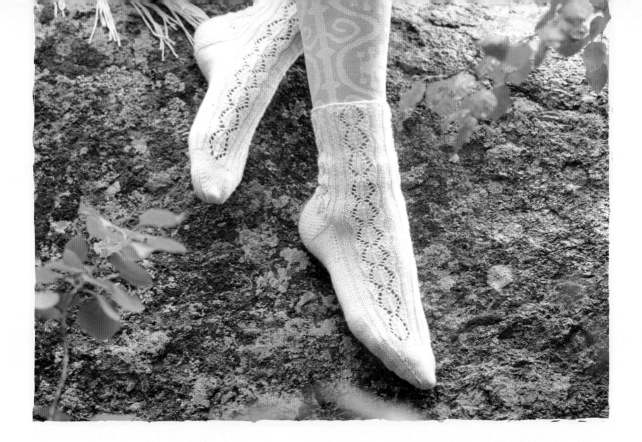

General Rules for Following Charts

- Review the key before you begin to make sure you understand the meaning of each symbol.

- Read charts from the bottom to the top. Each row on the chart represents one row or round of knitting; each cell in the chart indicates one stitch.

- When working back and forth in rows, right-side (RS) rows, which are numbered, are read from right to left; wrong-side (WS) rows are read from left to right.

- When working in rounds, all chart rows are considered right-side (RS) rows, and all are read from right to left.

- Many charts include "no stitch" symbols—gray cells instead of designated stitch symbols. These "no stitch" symbols are used as placeholders in the chart so that increases, decreases, and yarnovers align in the chart as they will in your knitting. When you come to a "no stitch" symbol, simply skip over it and continue with the next "real" stitch on the chart.

- Bold red and blue outlines indicate stitches and rows that are repeated. For example, when working a right-side row or round, work to the right edge of the repeat outline, then repeat the stitches within the outline the necessary number of times, then finish by working the stitches from the left of the outline to the edge of the chart.

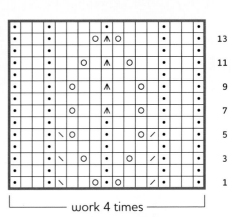

— work 4 times —

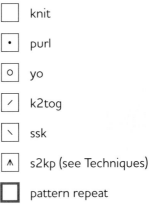

	knit
•	purl
o	yo
/	k2tog
\	ssk
∧	s2kp (see Techniques)
	pattern repeat

DECREASES

Knit 2 Together (k2tog)

This type of decrease slants to the right—one stitch decreased.

Knit two stitches together as if they were a single stitch.

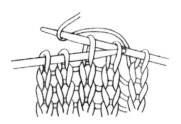

Slip, Slip, Knit (ssk)

This type of decrease slants to the left.

Slip two stitches individually knitwise **(Figure 1)**, insert the left needle tip into the front of these two slipped stitches, and use the right needle to knit them together through their back loops **(Figure 2)**—one stitch decreased.

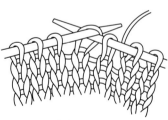

FIGURE 1

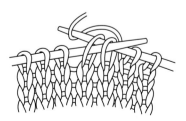

FIGURE 2

Centered Double Decrease (s2kp)

This type of decrease has a vertical alignment.

Slip two stitches together knitwise **(Figure 1)**, knit the next stitch **(Figure 2)**, then pass the slipped stitches over the knitted stitch **(Figure 3)**—two stitches decreased.

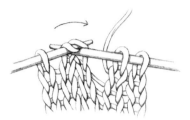

FIGURE 1

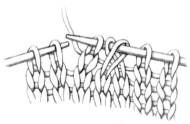

FIGURE 2

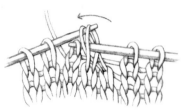

FIGURE 3

Knit 3 Together (k3tog)

This type of decrease slants to the right.

Knit three stitches together as if they were a single stitch—two stitches decreased.

Purl 3 Together (p3tog)

Purl three stitches together as if they were a single stitch.

Slip, Slip, Slip, Knit (sssk)

This type of decrease slants to the left.

Slip three stitches individually knitwise, insert the left needle tip into the fronts of these three slipped stitches, then use the right needle to knit them together through their back loops—two stitches decreased.

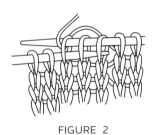

FIGURE 1

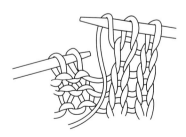

FIGURE 2

INCREASES

Yarnover:

After a Knit and Before a Purl

Beginning with the working yarn in the back of the needles, bring the yarn to the front of the work between the needles, then over the right needle and again to the front—wrapping the needle—and ready to purl the next stitch.

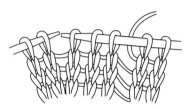

After a Purl and Before a Knit

Beginning with the working yarn in front of the needles, bring the yarn over the right needle to the back, ready to knit the next stitch.

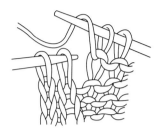

Between Two Knit Stitches

Beginning with the yarn in the back of the needles, bring the yarn to the front of the work between the needles, then over the right needle to the back, ready to knit the next stitch.

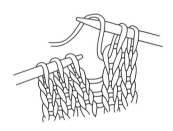

Between Two Purl Stitches

Beginning with the working yarn in front of the needles, bring the yarn over the top of the right needle to the back, then between the two needles to the front—wrapping the needle—and ready to purl the next stitch.

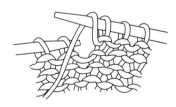

Double Yarnover

Wrap the yarn twice around the needle as described above. On the return row or round, work the two loops as purl 1, knit 1 when working back and forth, and knit 1, purl 1 when working in the round.

MANAGING DOUBLE-YARNOVERS AT THE START OF A ROUND

When you are working in the round and a double yarn-over spans the beginning of round (one of the yarnovers is at the start of the round and the second is at the end of the round), you need to decide if you want to work both at the beginning of the round or at the end. They must be worked together if you want your hex-mesh to be consistent. I like to work them at the beginning of the round. To do this, work a double yarnover at the beginning of the round, where the chart shows a single yarnover, and at the end of the round omit the final charted yarnover. When you work the return row remove the beginning-of-round marker, knit the first yarnover, replace your marker, and purl the second yarnover. Your start of round stays the same and your hex-mesh is uninterrupted and looks great!

If you work one of the yarnovers at the beginning and one at the end, you will have two yarnovers rather than a double yarnover, so your mesh will be interrupted at the beginning of round.

Lifted Yarnover (M)

This forms a smaller hole than a regular yarnover.

Use the left needle tip to lift the strand between the needle tips from front to back **(Figure 1)**, then knit the lifted loop *without twisting it*—one stitch increased.

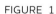

FIGURE 1

Making Multiple Stitches (\3/)

There are two ways this is done. In some instances the knitter alternates knitting and purling into the same stitch the specified number of times. If the number is 3, then knit 1, purl 1, knit 1 into the same stitch. If the number is 4, then knit 1, purl 1, knit 1, purl 1 into the same stitch, and so on. In some instances the knitter alternates knitting and making a yarnover into the same stitch the specified number of times, always ending with a knit. Review the chart key, which will give you details for each pattern, before beginning.

JOINING A NEW BALL OF YARN

When knitting lace, it's best to join a new ball of yarn as inconspicuously as possible.

Russian Join

This type of join works well with all types of yarn and is especially good when changing colors.

Thread the smallest needle possible with a 4" (10 cm) tail of the old yarn. Make a loop by inserting the needle back through the plies of the same yarn for about 1" (2.5 cm), then let the tail hang free, leaving a loop at the fold. Thread the end of the new yarn onto the needle, bring it through the loop in the old yarn, then insert it inside the plies of the new yarn in the same way to connect the two loops **(Figure 1)**. Pull the loose ends to tighten the loops **(Figure 2)**. Trim the remaining tails.

FIGURE 1

FIGURE 2

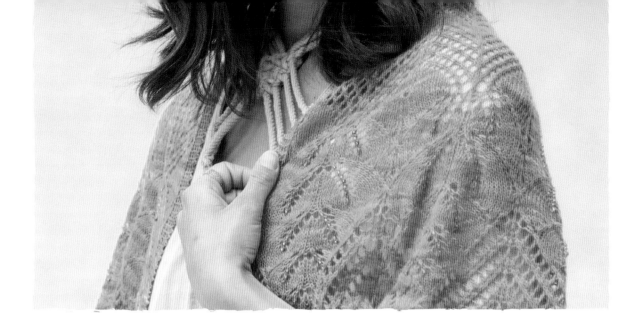

Spit Splicing

This method works only with feltable yarns such as wool and alpaca. It doesn't work for superwash wool, cotton, silk, or linen.

Untwist the plies from both the old and new ends of yarn for about 2" (5 cm) **(Figure 1)**, moisten the loose ends with saliva, overlap the loose ends **(Figure 2)**, then rub them vigorously between your palms **(Figure 3)**. The moisture and friction will cause the two yarn ends to felt together.

PICK UP STITCHES

Pick Up and Knit

With right side facing and working from right to left, *insert needle tip into the center of the stitch below the cast-on (or bind-off) edge **(Figure 1)**, wrap yarn around needle, and pull through a loop **(Figure 2)**. Repeat from * for the desired number of stitches.

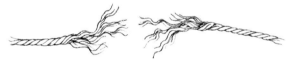

FIGURE 1

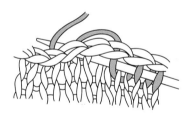

FIGURE 1

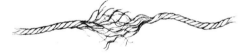

FIGURE 2

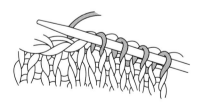

FIGURE 2

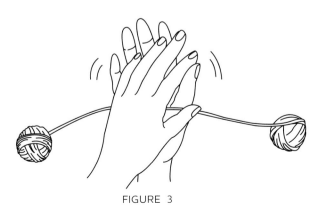

FIGURE 3

Pick Up and Purl

With wrong side of work facing and working from right to left, *insert needle tip under edge stitch from the far side to the near side **(Figure 1)**, wrap yarn around needle, and pull through a loop **(Figure 2)**. Repeat from * for the desired number of stitches.

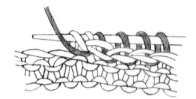

FIGURE 1

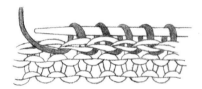

FIGURE 2

SHIFT THE BEGINNING OF A ROUND

Some patterns that are worked in rounds require that the beginning-of-round marker be shifted to the left or right on specific rounds. The charts for such patterns are clearly labeled. If the shift is to the left, just work the required number of stitches past the end of the round, then relocate the marker and resume with the first stitch of the next round. If the shift is to the right, simply stop working the required number of stitches before the end of the round, relocate the marker to this position, then continue with the first stitch of the next round.

STITCH MARKERS

Except to mark the beginning of the round when I'm working in rounds, I rarely use stitch markers other than for very specific situations. Although some designers advocate placing a marker at the end of every pattern repeat, I find that they can get in the way if the pattern repeat straddles a double decrease or the beginning of the round shifts from one position to another. In addition to the beginning-of-round marker, every other marker would have to be shifted as well. For example, if the instructions say to move the beginning of the round one stitch to the left, all the other markers will have to shift one stitch to the left as well.

When I do use markers, I choose smooth, thin markers that won't snag delicate yarn or affect the neighboring stitches. Otherwise, telltale "ladders" may appear in the finished piece. I also prefer markers that dangle a bit so that they won't inadvertently slip through yarnovers. Some of my favorite markers are ones that I've made from crochet cotton. Just cut crochet cotton that's finer than your working yarn into 3" (7.5 cm) lengths. Fold the lengths in half, then tie an overhand knot about halfway up the doubled thread to make a loop that's about ¾" (2 cm) long with ¾" (2 cm) tails.

I have written the patterns to reflect the method I feel works best for working in the round: When you work on the double-pointed needles, use the yarn end from your cast-on to mark the beginning of the round. A locking marker can be used to indicate the beginning of the round if that is your preferred method. There are drawbacks to this, such as the locking marker getting in your way when you begin at the center of a lace piece, the marker getting snagged on your yarn, and the time it takes to unlock and move the marker as you knit. Where you can choose to place a marker will be indicated in the pattern.

When working in the round, dealing with stitch markers when the beginning-of-round shifts can be challenging. I find it easier to use only one marker, at the beginning of round. If you want to use a marker between every chart repeat, I have two suggestions:

- The first is that you use a unique marker for your beginning of round because that one is critical.

- The second is that you treat each marker the same way you treat the beginning-of-round marker whenever there is a shift. When a double yarnover or a double decrease sits at the marker, you will have to "borrow" a stitch from the next repeat and therefore will have to move the marker one stitch over and return it to the original spot once you are done.

SEAMS

Overhand Stitch

Bring threaded needle down front to back through fabric on one side of seam, then up from back to front on other side; repeat from *, striving for even spacing of stitches.

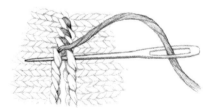

Kitchener Stitch (grafting)

Bring threaded needle through front stitch as if to purl and leave stitch on needle **(Figure 1)**.

Bring threaded needle through back stitch as if to knit and leave stitch on needle **(Figure 2)**.

Bring threaded needle through first front stitch as if to knit and slip this stitch off needle. Bring threaded needle through next front stitch as if to purl and leave stitch on needle **(Figure 3)**.

Bring threaded needle through first back stitch as if to purl and slip this stitch off needle. Bring needle through next back stitch as if to knit and leave stitch on needle **(Figure 4)**.

Repeat Steps 3 and 4 until no stitches remain on needles.

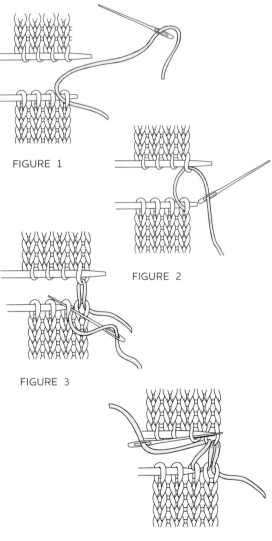

FIGURE 1

FIGURE 2

FIGURE 3

FIGURE 4

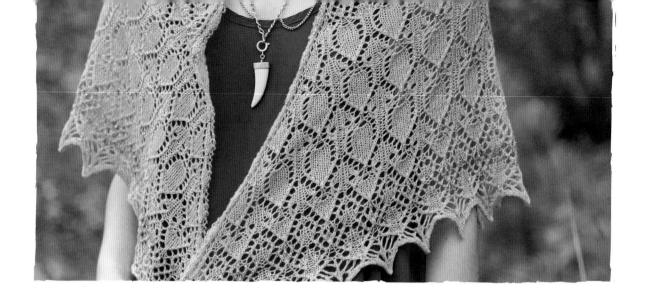

STITCHES

In addition to knits and purls, the following stitches are used in many of the projects in this book.

Twisted Knit (k1tbl)

Insert right needle through the loop on the back of the left needle from front to back **(Figure 1)**, wrap the yarn around the needle, and pull a loop through while slipping the stitch off the left needle **(Figure 2)**. This is similar to a regular knit stitch, but is worked into the back loop of the stitch instead of the front.

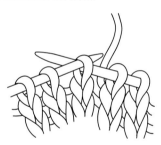

FIGURE 1

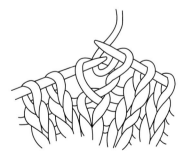

FIGURE 2

Twisted Purl (p1tbl)

Insert right needle through the loop on the back of the left needle from back to front **(Figure 1)**, wrap the yarn around the needle, and pull a loop through while slipping the stitch off the left needle **(Figure 2)**. This is similar to a regular purl stitch, but is worked into the back loop of the stitch instead of the front.

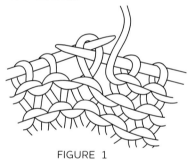

FIGURE 1

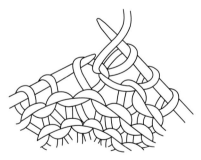

FIGURE 2

SELVEDGE STITCHES

Many knitters like to work a selvedge by slipping the first stitch of every row. However, I believe that slipped selvedge stitches are less elastic than knitted (or purled) stitches and can inhibit full blocking of a lace piece. Blocking is critical for all of the projects in this book and shouldn't be compromised by tight edges.

SPECIAL STITCHES

Nupps

With the right side of the work facing, work to the desired nupp stitch. Working very loosely knit into the designated stitch, but leave that stitch on the left needle. *Yarn over, then knit the stitch again **(Figure 1)**; repeat from * until the desired number of loops are on the needle (typically 7 or 9), ending by knitting into the stitch again to secure the last yarnover **(Figure 2; 7 nupp loops shown)**. If working in rows, purl the 7 or 9 nupp loops together on the following wrong-side row **(Figure 3; p7tog shown)**. If working in rounds, knit the 7 or 9 nupp loops together on the following round through their back loops.

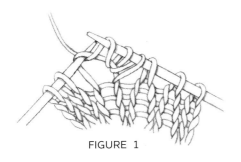

FIGURE 1

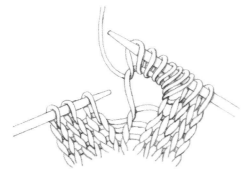

FIGURE 2

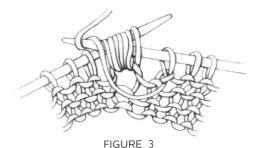

FIGURE 3

Two-Stitch Twist (cable)

Insert the tip of your right-hand needle between the first and second stitch on the left-hand needle. Knit the second stitch in the usual way **(Figure 1)**. Knit the first stitch **(Figure 2)**. Slip both stitches off the left-hand needle.

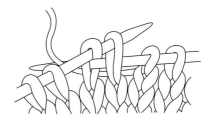

FIGURE 1

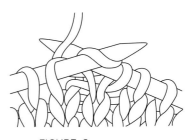

FIGURE 2

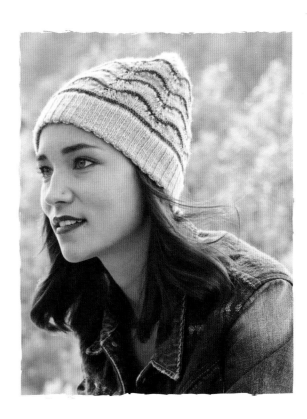

Chapter 3

THE FINE ART OF SWATCHING

Lace knitters are usually quick to skip swatching, because most lace accessories are not fit dependent. In *New Vintage Lace* (Interweave, 2014) I discuss several reasons lace knitters should embrace swatching. For one, we need to see what gauge works best for the yarn we selected. Another reason is that we need to see how the yarn works with our lace patterning. The busier the yarn's dye job, the more it can obscure our lace work.

© iStockphoto.com/ilbusca

Finally, getting gauge is important if you want to predict how many yards of yarn you need. Each project lists a particular yarn, worked at a particular gauge. The yardage specified is for that yarn over that gauge. When you make a substitution, consider that your yardage might vary from what is listed! If your project is worked flat, swatch flat. It your project is worked in the round, swatch in the round. Your gauge might differ.

I love swatching because it gives me the opportunity to try various materials at different gauges, and it helps me feel confident in my material choices.

Selecting beads for a lace knitting project is as important as selecting your yarn. Beads come in a myriad of colors and finishes, so the possibilities are almost infinite. When I choose beads for a project, I consider the size of the beads, the color, the shape, and the finish.

Bead Size: The larger the numerical designation, the smaller the bead! It is important to select a bead size that works with your yarn. The beads should fit comfortably on your yarn, as applied by a crochet hook. If they are too tight, you will struggle with each bead placement and run the risk of damaging your yarn. If they are too loose, they will slip out of place and be just too heavy for the yarn, pulling and potentially causing damage to your yarn. For most laceweight yarns, an 8/0 bead works well. For a heavier lace or fingering-weight yarn, you might need a 6/0 bead. For cobweb weight try an 11/0. Consider that larger beads weigh more. If you use larger beads on a fine yarn, they might weigh your fabric down and even damage the yarn.

Seed Bead Sizes

Seed Bead Sizes	
6/0	3.3 mm
8/0	2.5 mm
10/0	2 mm
11/0	1.8 mm
12/0	1.7 mm
15/0	1.3 mm

Bead Color: Selecting the perfect bead color for your yarn is one of the most enjoyable aspects of preparing for a project. I select my yarn first and then take my yarn bead shopping. I actually bring a crochet hook with me and try the bead options on my yarn before making a final selection. Check with your bead shop before opening tubes and trying beads on your yarn, but at my local bead shop

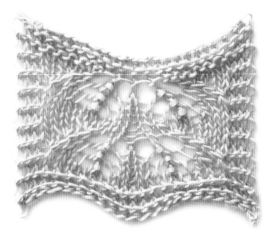

This swatch shows 8/0 and 6/0 beads in the same lace pattern. Beads are Miyuki silver-lined pale yellow alabaster.

they find us amusing! Bead placements in lace knitting can be used to outline motifs (such as in the coral swatch and scarf), as elements within a motif (such as a leaf stem as in the yellow swatch and scarf), or as design elements just about the beads themselves (such as the mauve swatch and scarf). They can also be used for subtle sparkle and to give your piece a little extra weight and drape. When using the beads as an outline or element within a lace motif, consider if you want striking or subtle contrast. I generally choose subtle to modest contrast, because I find that significant contrast becomes more about the beads and less about the lace work. When using beads in elements that are about the beads, contrast works well. If you are using beads for just a little sparkle and weight, avoid color contrast, but select a bead with sparkle, such as one that has a metallic lining.

Bead Shape and Finish: Beads come in various shapes, including round seed beads, cut (faceted) seed beads (such as Charlottes), hexagon, square, and triangle. Round seed beads can have a round or square hole. You can also choose cylinders (such as Delicas). Japanese seed beads are generally more uniform (both the size and shape and the hole) than other seed beads. I use either Japanese or Czech seed beads in my lace work. The Japanese beads are my go-to beads because of their uniformity, but the Czech beads are sometimes available in unique colors and finishes, so I forgo a little uniformity for that! The best way to select a bead shape is to try it on your yarn. Beads with edges (squares, hexes, cuts, triangles) create more sparkle than smooth beads. Cylinders are very smooth and uniform, so they can give a more "modern" or clean look. Beads come in many different finishes, and the finish can make a huge difference in the final look of your project. A silver-lined bead will glitter and stand out, even if the bead color matches your yarn perfectly, while a matte bead will visually disappear.

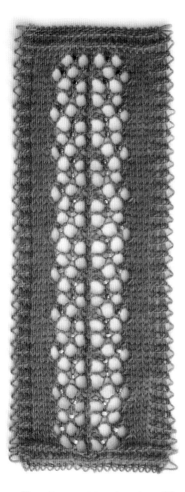
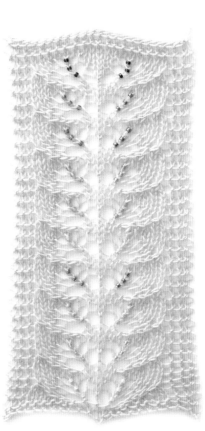
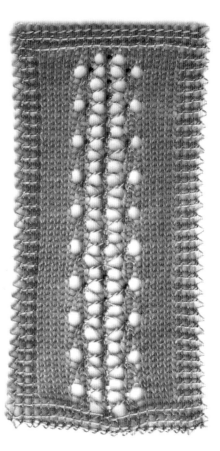

These three swatches show three different lace patterns in three different yarn colors, each using the same selection of beads in various colors to show off the different effects. (Names of the beads follow, with "AB" indicating "aurora borealis"): Miyuki silver-lined cobalt blue; Japanese silver-lined teal AB; Toho purple color-lined fuchsia; Miyuki silver-lined smoky amethyst AB; Miyuki silver-lined salmon alabaster; Miyuki matte transparent chartreuse AB; Metallic gold round; Miyuki Picasso canary yellow matte; Toho color-lined metallic antique gold AB; Miyuki silver-lined pale yellow alabaster

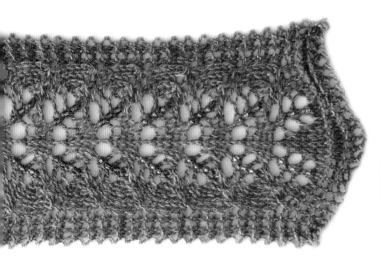

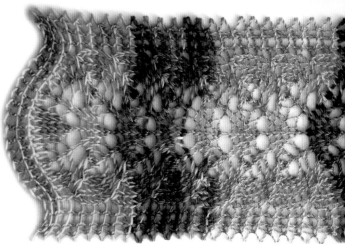

This swatch shows four different bead finishes in the same lace pattern. The names of the beads are: Czech silver-lined matte root beer; Japanese square-hole silver-lined root beer; Japanese metallic gold rounds; Toho olive-gold-lined crystal (clear)

If you want to experiment, try this swatch project: Each time you work the row repeat, try a different bead in the lace motif! A list of different bead finishes can be found on page 138.

This swatch shows a lace pattern (from left to right): hand-dyed tone-on-tone color, hand-dyed variegated color, commercially dyed solid color.

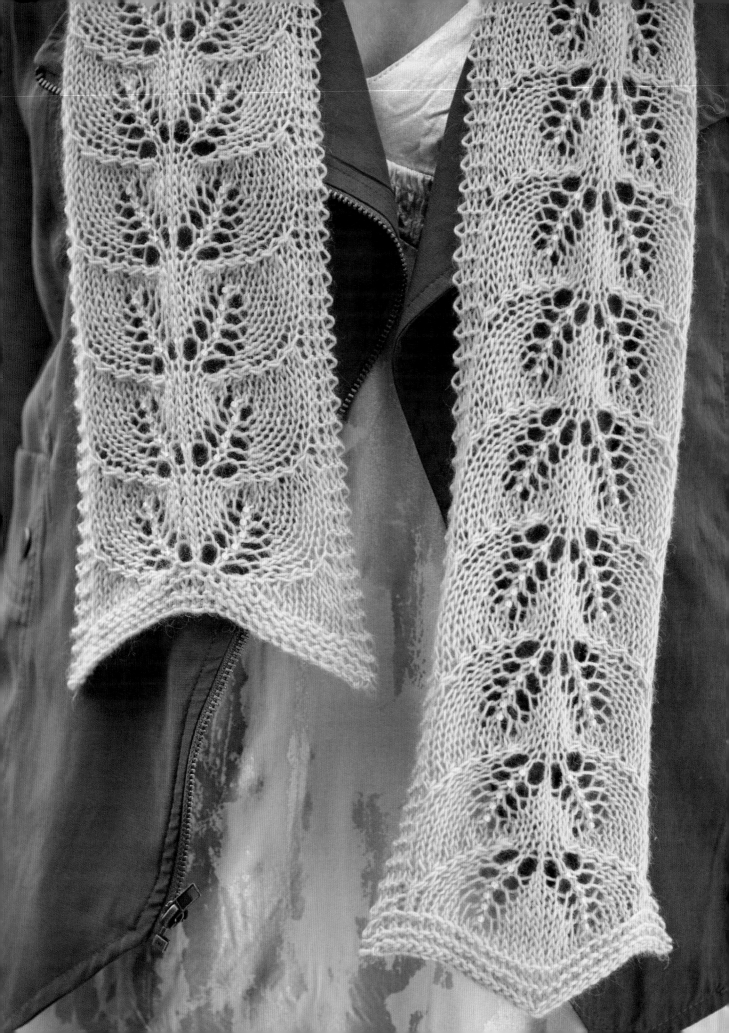

Breakneck Ridge

Storm King Scarves

Breakneck Ridge is a 2.8-mile (4.5 km) hike in Hudson Highlands State Park, New York. Although it is not a long hike, it requires both your hands and feet to get to the top. Some sections require just a little rock climbing; wear decent hiking shoes. The vistas are totally worth the effort. There are amazing views all along the climb, many across the Hudson River, including a view to Storm King Mountain. Climb early in the morning and enjoy a picnic breakfast while you watch the hawks soar. Sit and knit a little.

These scarves use repeating lace motifs to illustrate how beads can be used for differing effects in your lace knitting. They are great for practicing adding beads and working basic lace techniques, along with gaining comfort using charts. Feel free to use one type of bead, or try as many as you like and call it a bead sampler! Use the Beaded Swatch charts for more diminutive versions of these scarves.

FINISHED SIZE

Version A (yellow)

4¼" (11 cm) wide and 49" (124.5 cm) long.

Version B (coral)

4½" (11.5 cm) wide and 49" (124.5 cm) long.

Version C (mauve)

5" (12.5 cm) wide and 47½" (120.5 cm) long.

YARN

Laceweight (#0 Lace).

Shown here: Quince & Co. Piper (50% Texas superfine merino, 50% Texas super kid mohair; 305 yd [279 m]/50 g): #606 Amarillo (yellow, A), #607 Caracara (orange, B), and #608 Odessa (mauve, C). 1 skein of each will make a scarf, with enough left for bead samplers.

NEEDLES

Size U.S. 4 (3.5 mm): straight. *Adjust needle size if necessary to obtain the correct gauge.*

NOTIONS

20 g Miyuki 8/0 Japanese seed beads in pale yellow/silver-lined alabaster for Version A; Miyuki 8/0 Japanese seed beads in salmon/silver-lined alabaster for Version B; Toho 8/0 Japanese seed beads in purple color-lined fuchsia AB for Version C; size U.S. 14 (0.6 mm) steel crochet hook, or size to fit beads; tapestry needle; stainless T-pins; blocking mats; 2 long and 2 short blocking wires.

GAUGE

About 24 sts and 30 rows = 4" (10 cm) over St st, blocked and relaxed. Gauge is not critical to this project, though the size of your scarf and amount of yarn used may be different from the pattern.

NOTES

A word about slipping selvedge stitches: Don't! This piece was designed to block freely and slipped selvedge stitches will create a less flexible edge.

Beads: See Techniques.

The number of stitches cast on are listed for each version in this order: A (B, C). For all other instructions, the numbers apply to all three versions.

Every row is charted. Charts are worked flat; read all right-side (odd-numbered) rows from right to left and all wrong-side (even-numbered) rows from left to right.

These scarves look like rags before blocking. There is something about fine mohair and lace knitting. So as with all lace, plan to block these scarves to really appreciate them.

DIRECTIONS

CO 31 (31, 25) sts using long-tail method (see Techniques).

Beg desired chart and work Rows 1–16 once.

Rep Rows 7–16 twenty-eight more times. Note: For a longer scarf, rep Rows 7–16 additional times.

Work Rows 17–22 once.

BO row: K2, [return 2 sts just worked to left needle tip, k2tog tbl, k1] to last 2 sts, k2, return 2 sts just worked to left needle tip, k2tog tbl. Cut yarn leaving 9" (23 cm) tail, pull tail through rem st.

FINISHING

Weave in all ends but do not trim. Soak in cool water until fully saturated (about 30 minutes). Press to remove water, roll piece in a towel, and blot to remove extra water.

Weave a long blocking wire through the vertical strands in garter st along each long edge of scarf. Note: For Versions B and C you can weave a short wire along each short edge, and for Version A use T-pins to pull out the pattern's natural scallop.

Pin wires to 5½ (5½, 5)" (14 [14, 12.5] cm) wide and 52" (132 cm) long. Allow to dry completely. Scarf will relax to finished measurements after unpinning. Trim ends.

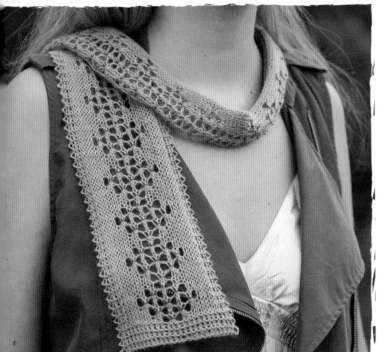

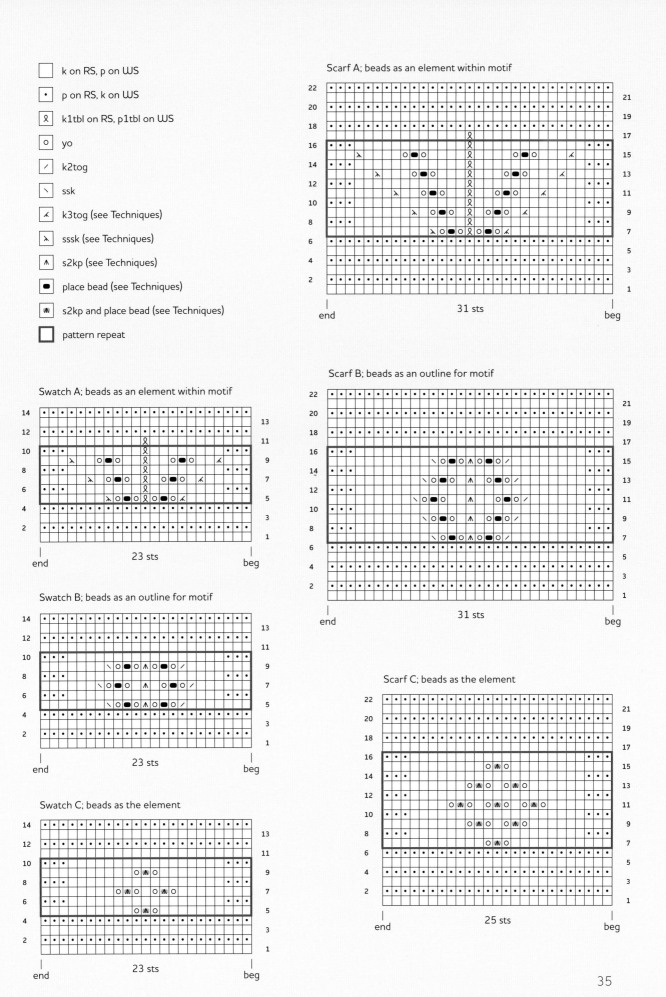

k on RS, p on WS

• p on RS, k on WS

ℓ k1tbl on RS, p1tbl on WS

o yo

∕ k2tog

∖ ssk

⊀ k3tog (see Techniques)

⅄ sssk (see Techniques)

∧ s2pk (see Techniques)

▪ place bead (see Techniques)

▲ s2pk and place bead (see Techniques)

pattern repeat

Scarf A; beads as an element within motif

31 sts

end beg

Swatch A; beads as an element within motif

23 sts

end beg

Swatch B; beads as an outline for motif

23 sts

end beg

Swatch C; beads as the element

23 sts

end beg

Scarf B; beads as an outline for motif

31 sts

end beg

Scarf C; beads as the element

25 sts

end beg

Chapter 4

PROJECTS 1: HIKES, TREKS, AND MODERATE CLIMBS

There are so many amazing hikes that it was hard to select a few to highlight. The following projects are assorted classic treks that mountaineers might "warm up" on. Think of these knitting projects as "warm-ups" for the more challenging pieces to come.

© iStockphoto.com/Urmas83

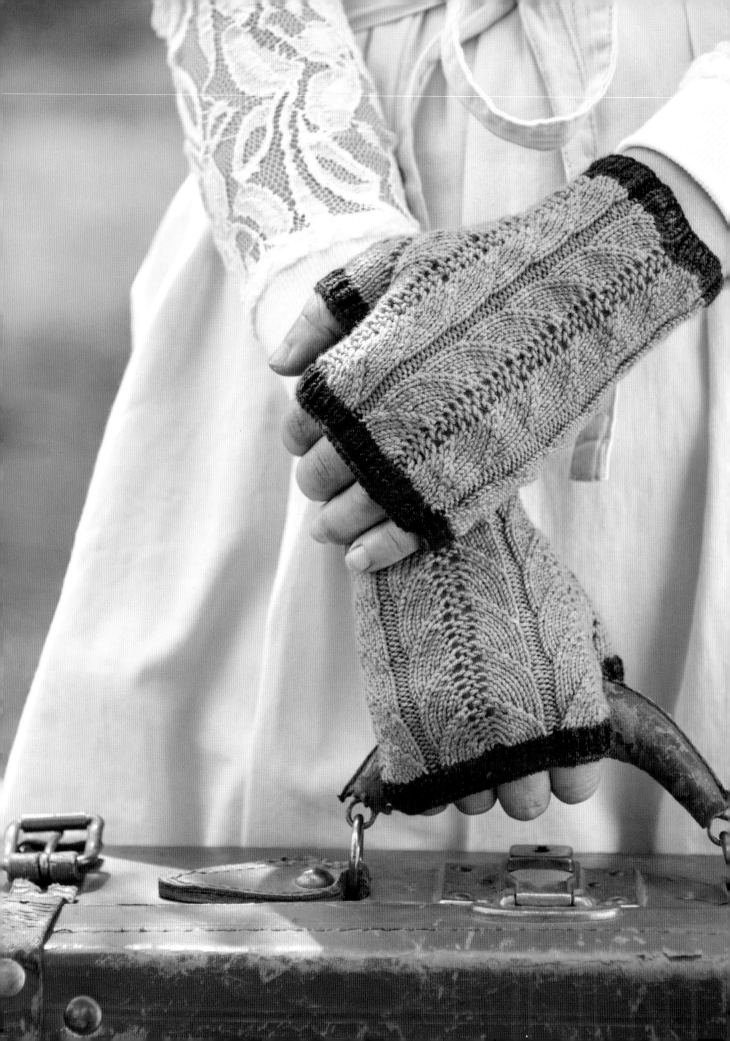

Costa Rica

Corcovado Mitts

Corcovado National Park is a large area of dense rainforest and is home to one of Costa Rica's largest populations of scarlet macaws. It is strenuous hiking, but the reward is some of Costa Rica's most beautiful and unspoiled rainforest.

These mitts use a yarn with lots of memory, so they fit a variety of hand sizes very well.

FINISHED SIZE

One size fits most women's hands.

5½" (14 cm) hand circumference and 6½" (16.5 cm) long, relaxed.

YARN

Fingering weight (#1 Super Fine).

Shown here: Alchemy Yarns of Transformation Juniper (100% superfine merino; 232 yd [212 m]/50 g): #78c Pablo's Solace (purple, A) and #76e Citrine (bright green, B), 1 skein each.

NEEDLES

Size U.S. 1 (2.25 mm): set of 5 double-pointed (dpn). *Adjust needle size if necessary to obtain the correct gauge.*

NOTIONS

Locking marker (m) (optional); stitch holder or smooth waste yarn; tapestry needle.

GAUGE

60 sts and 48 rnds = 4" (10 cm) over Hand chart patt, blocked and relaxed.

NOTES

One 15-stitch repeat is worked once on each double-pointed needle in each round.

When changing colors, cut the old color and begin working with the new color leaving a 6" (15 cm) tail for each yarn. At the end, snug things up and weave all ends on the wrong side.

When you work on the double-pointed needles, use the yarn end from your cast-on to mark the beginning of the round. A locking marker can also be used if desired.

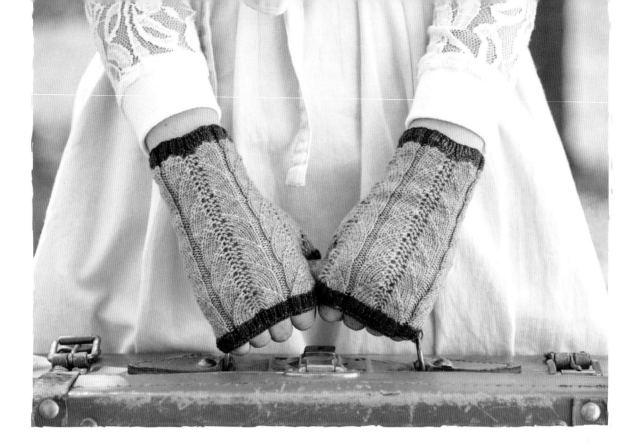

DIRECTIONS

With dpn and A, CO 60 sts. Divide sts evenly over 4 dpn with 15 sts on each needle. Place yarn end or marker (pm) and join for working in rnds, being careful not to twist sts.

Work Rnds 1–6 of Hand chart.

Change to B.

Work chart Rnds 7–22 once, then rep Rnds 13–22 once more.

Thumb Gusset
Next (inc) rnd: Work Row 1 of Thumb chart, pm, work next row of Hand chart to end—1 st inc'd.

Work 23 rnds in established patts, ending with Rnd 46 of Hand chart and Rnd 24 of Thumb chart—83 sts; 60 sts for hand, and 23 sts for thumb gusset.

Next rnd: Sl 23 sts for thumb onto holder or smooth waste yarn, removing m if using. Work next rnd of Hand chart to end, making sure to pull Needles 1 and 4 tog to avoid leaving a gap at the thumb gusset—60 sts rem.

Work Rnds 48–62 in established patt.

Change to A.

Work Rnds 63–88 in established patt.

BO rnd: K2tog tbl, [return dec st to left needle, k2tog tbl] to end, making sure to not work too loosely. Cut yarn leaving a 6" (15 cm) tail, pull tail through rem st.

Thumb
Return 23 held thumb sts to 3 dpn.

Next rnd: With B, work Thumb chart Row 25, insert LH needle tip from front to back, under bar between sts at "crotch" at top of thumb, k1tbl—24 sts. Distribute sts evenly if necessary with 8 on each dpn. Pm for beg of rnd, if using, and join for working in rnds

Work 1 rnd in established patt.

Change to A.

Work Rnds 27–32 in established patt.

BO same as for hand.

Make second mitt same as first.

FINISHING

Weave in loose ends, making sure to close up any holes, especially at top of thumb, but do not trim. Soak in cool water until fully saturated (about 30 minutes). Press to remove water, roll in a towel, and blot to remove extra water. Lay flat to dry. Trim ends.

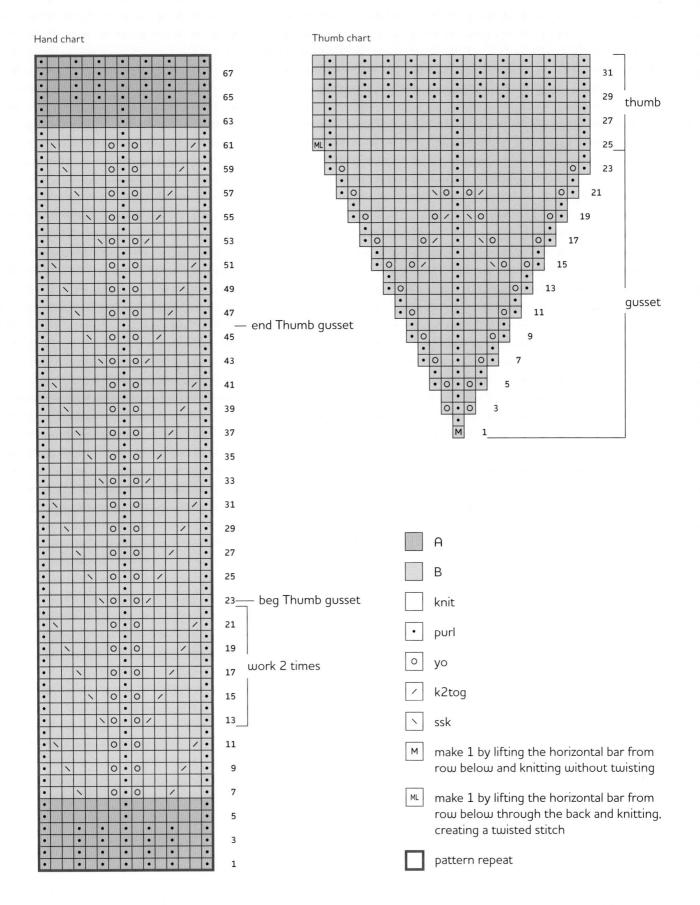

Hand chart

Thumb chart

thumb

gusset

67
65
63
61
59
57
55
53
51
49
47 — end Thumb gusset
45
43
41
39
37
35
33
31
29
27
25
23 — beg Thumb gusset
21
19
17 work 2 times
15
13
11
9
7
5
3
1

31
29
27
25
23
21
19
17
15
13
11
9
7
5
3
1

A

B

knit

• purl

O yo

╱ k2tog

╲ ssk

M make 1 by lifting the horizontal bar from row below and knitting without twisting

ML make 1 by lifting the horizontal bar from row below through the back and knitting, creating a twisted stitch

pattern repeat

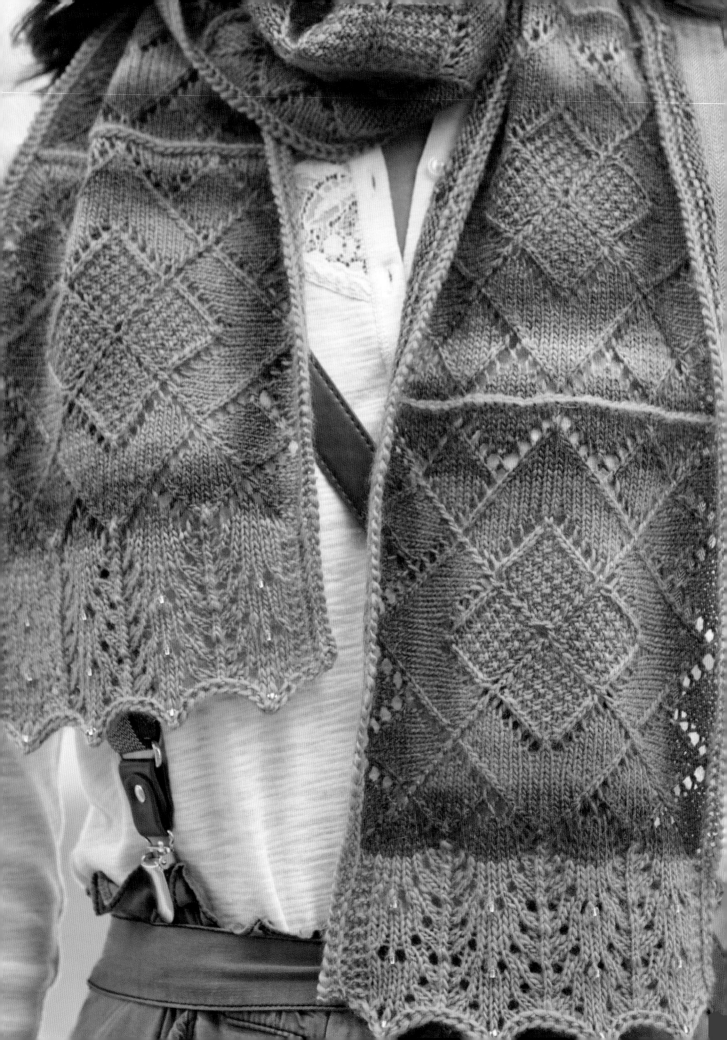

Kathmandu
Prayer Flag Scarf

Kathmandu, the capital of Nepal, is the gateway for all travelers to that country. While hopeful climbers of Mount Everest begin in Kathmandu and then provision and leave, Kathmandu is a city rich in history and charm, worthy of exploration.

One of the most famous treks is the hike to Mount Everest's base camp. This trip can take from fourteen to twenty-one days and is strenuous and at high altitude. Inspired by faded but still bright prayer flags on the mountains, this scarf or wrap is made of modular squares in bright colors. Each square is worked from the center out on double-pointed needles and then joined.

This piece can be made wider or longer very easily. It would make a lovely stole or baby blanket.

FINISHED SIZE

6½" (16.5 cm) wide and 57½" (146 cm) long.

YARN

Fingering weight (#1 Super Fine).

Shown here: Crystal Palace Mini Mochi (80% merino, 20% nylon; 195 yd [178 m]/50 g): #105 Tapestry Rainbow (A), 2 balls; #1110 Lily Pad (B), 1 ball.

See Notes on calculating yarn amounts for making a larger scarf.

NEEDLES

Size U.S. 2 (2.75 mm): set of 5 double-pointed (dpn) and 16" (40 cm) and 32" (80 cm) circular (cir). *Adjust needle size if necessary to obtain the correct gauge.*

NOTIONS

Locking marker (m) (optional); smooth waste yarn; 24 size 6/0 Czech seed beads in gold-lined crystal; size U.S. 16 (0.6 mm) steel crochet hook, or size to fit beads; tapestry needle; stainless T-pins; blocking mats; 4 short rigid blocking wires for squares; 4 long (or 2 very long) rigid blocking wires for scarf.

GAUGE

Each square = 6½" (16.5 cm) square, blocked and relaxed.

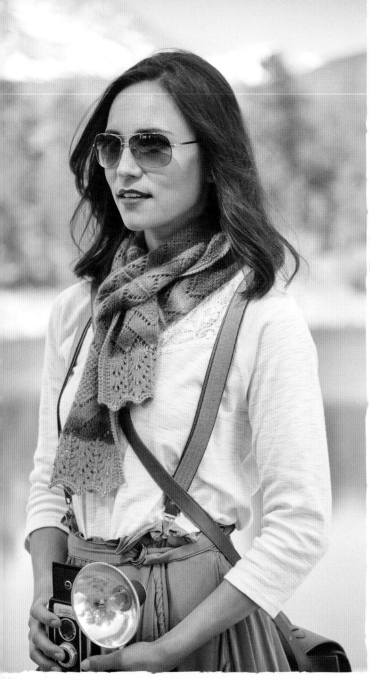

NOTES

Beads: See Techniques.

When you work on the double-pointed needles, use the yarn end from your cast-on to mark the beginning of the round. A locking marker can also be used if desired.

Every row is charted. Chart A is worked in the round; read all chart rows from right to left. Chart B is worked flat; read right-side (odd-numbered) rows from right to left and wrong-side (even-numbered) rows from left to right.

It is very simple to make this piece larger, in both width and length. One ball of the specified yarn will make four or five squares. Each square is 6½" (16.5 cm) square, relaxed after blocking. So you can make the piece longer or wider in 6½" (16.5 cm) increments. Be sure you get more yarn if you make the piece larger. If you make it wider, you will have to join the strips lengthwise using three-needle bind-off, and then work additional repeats of chart B across each edge.

I intentionally made each square different by starting at a different point in the yarn's color sequence. To allow for even more options, I wound some of the yarn to reverse the color sequence.

DIRECTIONS

Square 1

With dpn and A, CO 8 sts using long-tail method (see Techniques). Distribute sts evenly over 4 dpn, with 2 sts on each needle. Use yarn end or place marker (pm) for beg of rnd and join for working in rnds, being careful not to twist sts.

Rnd 1: [P1, k1tbl] 4 times.

Next rnd: Work Rnd 1 of chart A 4 times around—8 sts inc'd.

Work Rows 2–36 as est, changing to cir needle when there are too many sts to work comfortably on dpn—152 sts, with 38 sts in each section.

Cut a piece of waste yarn at least 35" (89 cm) long. Place sts onto waste yarn and knot ends tog.

Squares 2–8

Make same as for square 1 (see Notes about beginning each square in a different point in the yarn's color sequence).

Chart A

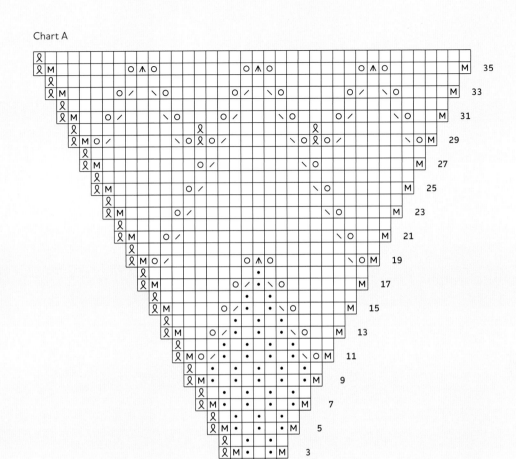

work 4 times

k on RS, p on WS

· p on RS, k on WS

Ɛ k1tbl

○ yo

╱ k2tog

╲ ssk

⋀ s2kp (see Techniques)

● place bead (see Techniques)

M make 1 by lifting horizontal bar from row below and knit without twisting

pattern repeat

Chart B

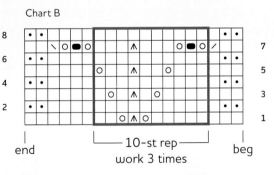

10-st rep
work 3 times

end

beg

TIPS AND TRICKS

Use yarn tail from the cast-on as your marker while on the double-pointed needles.

FINISHING

Weave in CO tails of squares but do not trim. Soak in cool water until fully saturated (about 30 minutes). Press to remove water, roll in a towel, and blot to remove extra water. Slip a rigid blocking wire in each edge of square, and pin out to 7" (18 cm) square.

Allow to dry completely before removing pins and wires. Squares will relax to finished measurements after removing pins. Trim ends of CO tails.

Joining Squares

Note: When joining the squares, leave the waste yarn in place until all the squares are joined and the edging has been worked. Be careful not to split the waste yarn when returning stitches to the needles.

Return held 39 sts (from one twisted corner st to next twisted corner st) along one side of first square to one dpn leaving waste yarn in place until the end. Rep with a second square.

Holding 2 dpn parallel and with WS tog (RS facing out), with B, join squares using three-needle BO (see Techniques).

*Return held 39 sts along the opposite edge of square 2, from twisted corner st to next twisted corner st onto dpn as before.

Return held 39 sts along one side of third square to one dpn. Holding 2 dpn parallel and with WS tog, use B to join squares using three-needle BO.

Rep from * until all squares have been joined.

Lace Edging

Return held 39 sts along opposite end of last square to shorter cir needle. Join B to beg with a RS row.

Row 1: Beg at right edge of chart B, work 3 sts, work 10-st rep 3 times, then work 6 sts at left edge of chart.

Work Rows 2–8 of chart as established. Rep Rows 1–8 once more, then work Rows 1–7 once.

Next row: (WS) Knit.

BO row: (RS) K2, [return 2 sts just worked to left needle tip, k2togtbl, k1] to last 2 sts, k2togtbl. Cut yarn leaving 9" (23 cm) tail, pull tail through rem st.

Work edge along rem short end same as first.

Side Edging

With longer cir needle, with B, and with RS facing, pick up and knit 13 sts in vertical strands of garter st along side of lace edging, pick up and knit 1 st in twisted corner st, [knit held 37 sts, pick up and knit 1 st in join between squares] 7 times, knit held 37 sts, pick up 1 st in twisted corner st, then pick up and knit 13 sts along side of lace edging—331 sts.

Next row: (WS) Knit.

BO same as for lace edging.

Work edging along rem long side same as first.

Remove all waste yarn carefully.

Weave in all ends, neatening up beg and end of each three-needle BO.

Soak in cool water until fully saturated (about 30 minutes). Press to remove water, roll in a towel, and blot to remove extra water. Weave one or two long wires along BO edge of each long edge. Pin wires out to even width. Pin out points along short edges at beads.

Allow to dry completely before removing pins and wires. Trim ends.

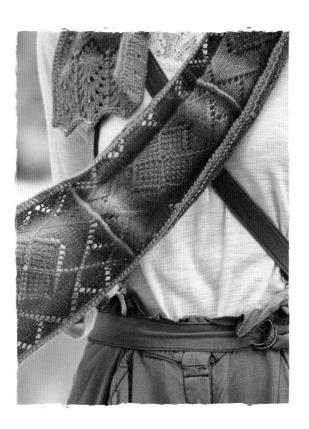

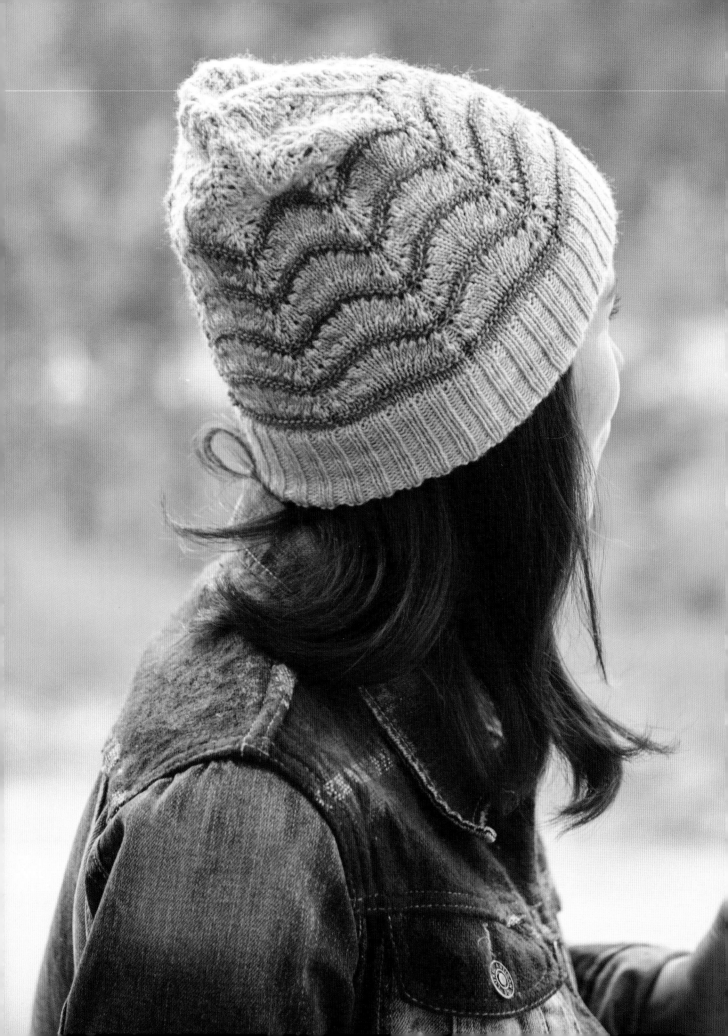

The Inca Trail

Machu Picchu Beanie

The Inca Trail (also known as Camino Inca) is the classic trek to Machu Picchu. Located in the Andes mountain range, the trail brings you through several unique environments including cloud forests and alpine tundra. You pass villages and Incan ruins before arriving at the Sun Gate on Machu Picchu.

This project uses a center cast-on and double-pointed needles and begins at the top. It combines a classic take on a feather-and-fan-lace stitch with contrasting colored purl ridges, plus a double ribbed band to keep your ears warm. The combination of colors and stitches is both modern and classic at the same time. The band uses a purl ridge to create a neat fold and is stitched down on the inside, for a really clean and elastic finish.

FINISHED SIZE

16" (40.5 cm) brim circumference and 8¾" (22 cm) tall.

YARN

Fingering weight (#1 Super Fine).

Shown here: Madelinetosh Unicorn Tails (100% superwash merino; 52 yd [47 m]/ 12g): Silver Fox (A), 2 skeins; Celadon (B), 2 skeins; Charcoal (C), 1 skein.

NEEDLES

Size U.S. 1 (2.25 mm): set of 5 doubled-pointed (dpn), and 16" (40 cm) circular (cir). *Adjust needle size if necessary to obtain the correct gauge.*

NOTIONS

Locking marker (m) (optional); waste yarn; tapestry needle.

GAUGE

34½ sts and 42 rnds = 4" (10 cm) over chart B, blocked.

NOTES

A fine yarn alternative is to get a full skein of the Tosh Merino Light and use one color for the entire piece.

When joining a new color, always bring the new color from under the old color. When changing colors, cut the old color leaving a 6" (15 cm) tail, and leave a 6" (15 cm) tail when joining the new color. When working chart B, do not cut color C when changing colors but carry it up the wrong side of the work, making sure you do not pull it tightly. Once you weave in the yarn tails, the joins will be invisible.

When you work on the double-pointed needles, use the yarn end from your cast-on to mark the beginning of the round. A locking marker can also be used if desired.

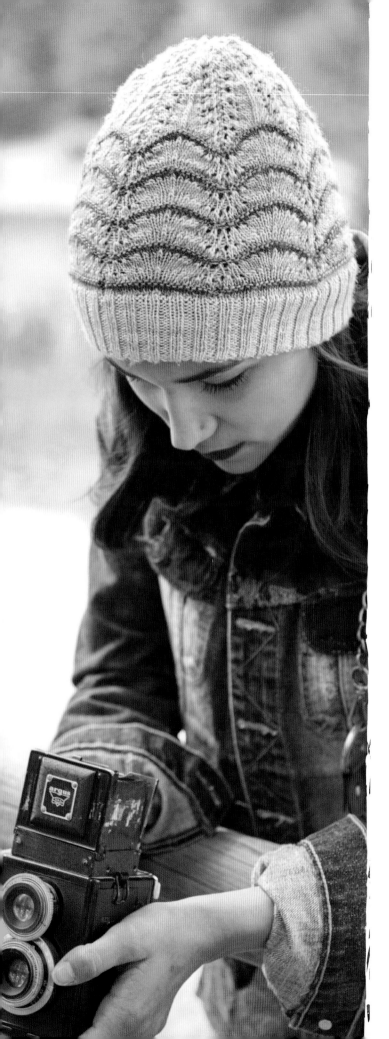

DIRECTIONS

With dpn and A, CO 8 sts using the long-tail method (see Techniques). Distribute sts evenly over 4 dpn, with 2 sts on each needle. Use yarn end or place marker (pm) for beg of rnd, and join for working in rnds, being careful not to twist sts.

Rnd 1: Work Rnd 1 of chart A—8 sts inc'd.

Work Rnds 2–38 in established patt—160 sts. Change to cir needle when there are too many sts to work comfortably on dpn.

Work Rnds 1–14 of chart B once. Rep Rnds 3–14 three more times. Work Rnds 15–20 once.

Next rnd: P1, *k2, p2; rep from * to last 3 sts, k2, p1.

Rep last rnd 21 more times. Ribbing should measure about 2¾" (7 cm).

Next (turning) rnd: Purl.

Cont in ribbing until most of A is used, ending at beg of rnd.

Change to B and work in ribbing until most of yarn is used, ending at beg of rnd.

Change to C and work in ribbing until a total of 21 rnds have been worked after the turning rnd. Do not cut yarn.

Cut a piece of waste yarn about 24" (61 cm) long. Slip sts kwise onto waste yarn.

Weave in ends and trim ends in ribbing area.

Turn ribbing to inside along turning rnd. Thread rem end of C onto tapestry needle, sew sts to final chart rnd worked in B, using overhand st (see Techniques) to sew through the purl bumps on WS, making sure not to pull tightly. Note: Leave waste yarn in place until seam is complete, then fasten off C and remove waste yarn.

FINISHING

Weave in rem ends but do not trim. Soak in cool water until fully saturated (about 30 minutes). Press to remove water, roll in a towel, and blot to remove extra water. Lay piece flat and finger block to finished measurements. Allow to dry completely. Trim ends.

	A
	B
	C
	knit
•	purl
ℓ	k1tbl
o	yo
∕	k2tog
＼	ssk
∧	s2kp (see Techniques)
	pattern repeat

TIPS AND TRICKS

To cast on using double-pointed needles, I like to cast on all the stitches onto one needle. I then move stitches to another 2 needles. In this case, cast on 8 stitches to one double-pointed needle. Slip 4 stitches from the right side of the needle to a second double-pointed needle. Slip 2 stitches from the right side of the second needle to a third double-pointed needle. Bring the needles away from you and together to join your work. Then rotate the work toward you so that the join is in front of you and ready to knit. After working a few rounds, add a fourth double-pointed needle so you are working chart A twice on each of the four needles.

Chart A

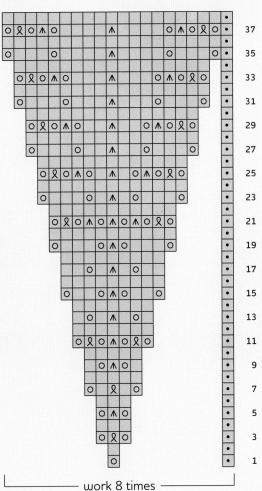

work 8 times

Chart B

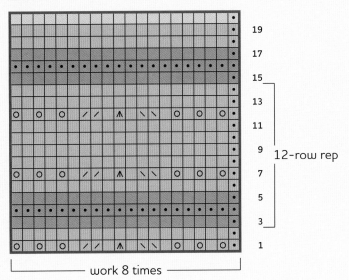

work 8 times

12-row rep

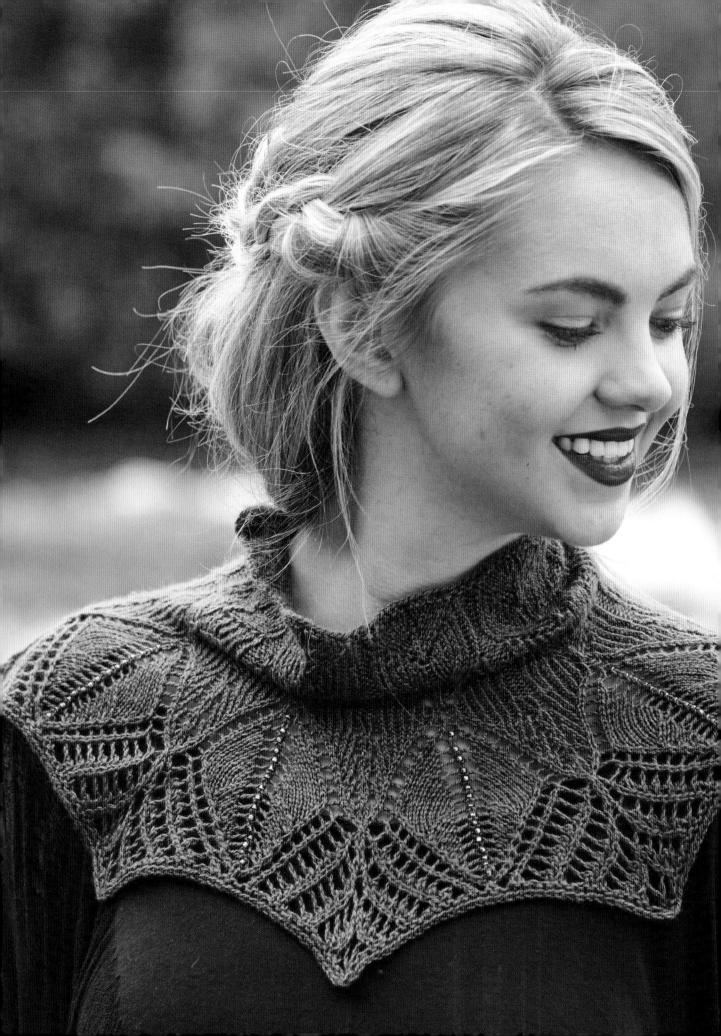

Chamonix to Zermatt

Alpine Garden Cowl

The Haute Route takes you from the Chamonix Valley, France, near Mont Blanc to Zermatt, Switzerland, and the Matterhorn. During warmer months you can hike, but during the winter skiing gear is mandatory! It takes about twelve days on foot and closer to seven on skis, but there are alpine huts and small inns along the way.

This project is worked in the round using twisted stitches and beads for texture.

FINISHED SIZE

41" (104 cm) bottom circumference, 16" (40.5 cm) top circumference, and 9½" (24 cm) long at longest point.

YARN

Laceweight (#0 Lace).

Shown here: Jade Sapphire Silk Cashmere 2-ply (55% silk, 45% Mongolian cashmere; 400 yd [366 m]/55 g): #024 Plum Rose, 1 skein.

NEEDLES

Size U.S. 3 (3.25 mm): 16" (40 cm) circular (cir). *Adjust needle size if necessary to obtain the correct gauge.*

NOTIONS

Markers (m); 130 Toho 8/0 Japanese seed beads in purple color-lined Fuchsia AB; size U.S. 14 (0.6 mm) steel crochet hook, or size to fit beads; tapestry needle; stainless T-pins; blocking mats; mixing bowl with 7" (18 cm) diameter; 1 yd (1 m) cotton tape or cord.

GAUGE

24 sts = 4" (10 cm) over St st, blocked and relaxed.

NOTES

Beads: See Techniques.

Two-Stitch Twist (Cable): See Techniques

Two-Stitch Twists (cables) are worked on chart B Rnds 5, 9, 13, and 17. To work these cables, end the previous round one stitch before the end of the round and use that stitch as the first of the two cable stitches as follows: *Slip 1, remove marker, place slipped stitch back on left needle tip. Skip first stitch and knit into the back of the second stitch on the left needle, knit first stitch, then slip both stitches off the needle, slip the last stitch just worked back to left needle tip, replace marker, slip stitch back to right needle. If you are using markers, work to 1 stitch before the next marker; repeat from*, or simply work around as charted, without markers to the last stitch, k1tbl.

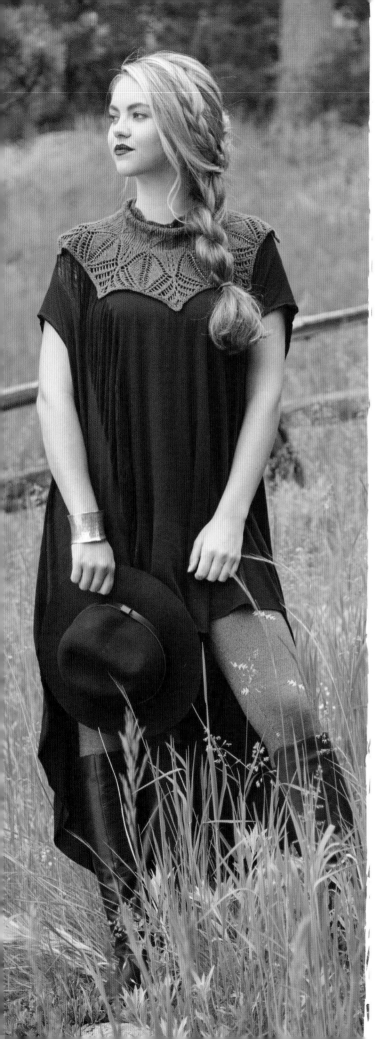

The use of stitch markers between repeats is not necessary, and might slow you down, but are optional if you like. If you choose not to use markers between repeats, the two-stitch cables can be worked as charted without needing to remove and replace the markers as described above.

Rounds 29 and 35 of chart B involve a double yarnover at the beginning and end of each repeat. If you use markers be sure to keep the markers between yarnovers, before slipping the beginning-of-round marker, *yarnover, slip marker, yarnover, work to the next marker; repeat from * 6 more times, yarnover, slip marker, yarnover, work to the last stitch, k1.

DIRECTIONS

CO 120 sts using the long-tail method (see Techniques). Place marker (pm) for beg of rnd, and join for working in rnds, being careful not to twist sts.

Knit 1 rnd.

Purl 1 rnd.

Next rnd: Work 15-st rep of Rnd 1 of chart A 8 times around.

Work Rnds 2–14, then rep Rnds 1–14 twice more.

Next rnd: Work 15-st rep of Rnd 1 of chart B 8 times around—8 sts inc'd.

Work Rnds 2–40 once—280 sts.

BO as foll: K2togtbl, return dec st just worked to left needle tip, k2togtbl, [k1tbl, return 2 sts just worked to left needle tip, k2togtbl] around. Cut yarn leaving a 6" (15 cm) tail, pull tail through rem st.

FINISHING

Weave in ends but do not trim. Soak in cool water until fully saturated (about 30 minutes). Press to remove water, roll in a towel, and blot to remove extra water.

Block the piece as foll: Place the mixing bowl, upside down, on the blocking mats. Place the cowl over the top of the bowl with narrow end up. Pin out the points of each chart B section to create a circle 41" (104 cm) in circumference. Tie the cotton cord around the piece about 1" (2.5 cm) from the bottom of the mixing bowl, to prevent the neck from stretching as it blocks. Allow to dry completely. Trim ends.

Chart A

Chart B

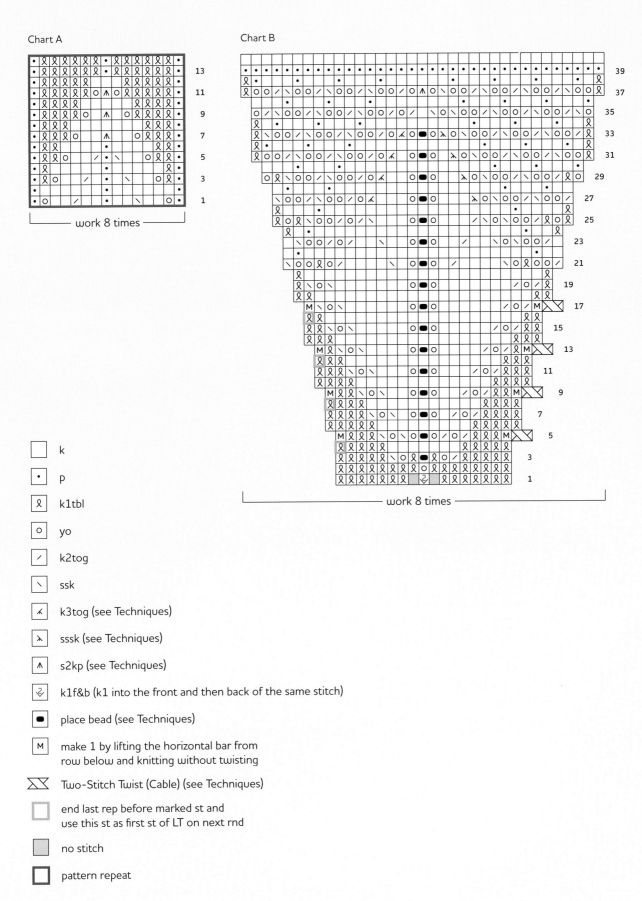

work 8 times

work 8 times

	k
•	p
ℓ	k1tbl
o	yo
╱	k2tog
╲	ssk
⋌	k3tog (see Techniques)
⋋	sssk (see Techniques)
∧	s2kp (see Techniques)
⏃	k1f&b (k1 into the front and then back of the same stitch)
●	place bead (see Techniques)
M	make 1 by lifting the horizontal bar from row below and knitting without twisting
⧄⧅	Two-Stitch Twist (Cable) (see Techniques)
	end last rep before marked st and use this st as first st of LT on next rnd
	no stitch
	pattern repeat

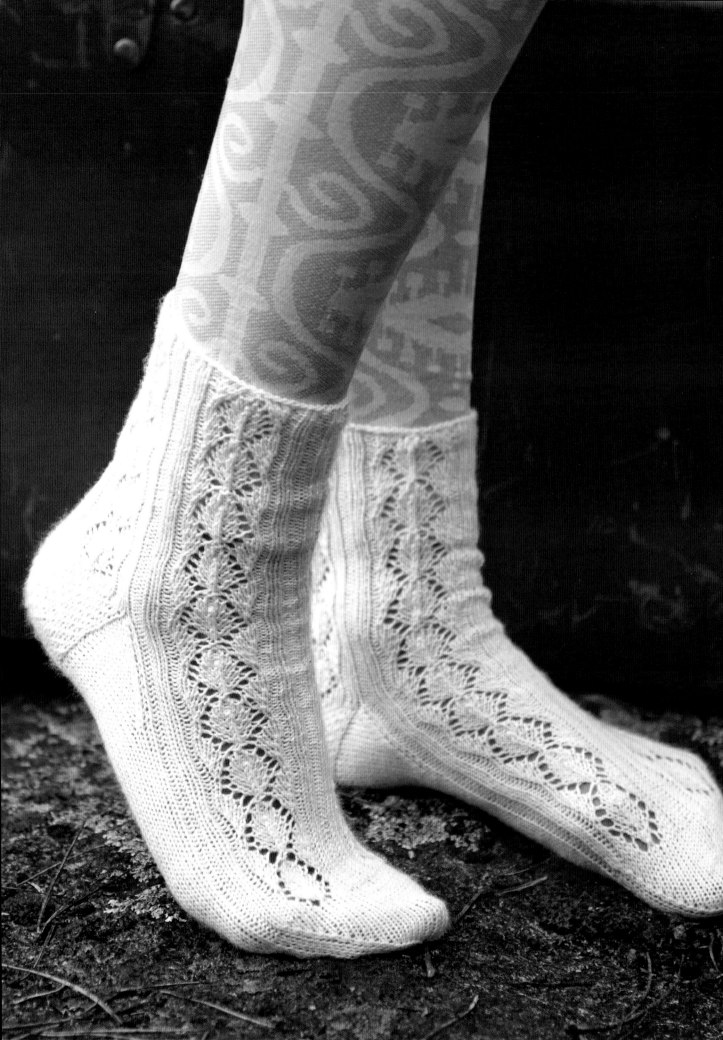

Mont Blanc

Chamonix Lace Socks

Mont Blanc means "white mountain" in French. It is the highest mountain in the European Union, rising to 15,781 feet (4,810 m) above sea level. The eleventh-highest mountain in the world, it is known as La Dame Blanche, which means "the white lady" in French. In 1786, Jacques Balmat and Michel Paccard made the first documented ascent, and some people consider this the beginning of "modern" mountaineering. Although Mont Blanc is the highest mountain within the European Union, it is not the highest mountain on the continent! But I consider this an honorable mention.

FINISHED SIZE

6½" (16.5 cm) foot circumference and 7" (18 cm) leg length to bottom of heel.

YARN

Fingering weight (#1 Super Fine).

Shown here: Crystal Palace Panda Silk (52% bamboo, 43% merino, 5% silk; 204 yd [187 m]/50 g): #3204 Natural Ecru, 2 skeins.

NEEDLES

Size U.S. 1 (2.25 mm): set of 5 double-pointed (dpn). *Adjust needle size if necessary to obtain the correct gauge.*

NOTIONS

Locking marker (m) (optional); tapestry needle; sock blockers (optional).

GAUGE

37 sts and 52 rnds = 4" (10 cm) over St st, blocked; 42 sts and 52 rnds = 4" (10 cm) over lace patt, blocked.

STITCH GUIDE

W&t (wrap and turn): On knit side, work to the turning point, slip next stitch purlwise, bring the yarn to the front, then slip the same stitch back to the left needle, turn the work around and bring the yarn in position for the next stitch. On the purl side, work to the turning point, slip the next stitch purlwise to the right needle, bring the yarn to the back of the work, return the slipped stitch to the left needle, bring the yarn to the front between the needles and turn the work so that the RS is facing and the yarn is in position for the next stitch.

NOTES

These socks use classic top-down sock techniques. In place of the more typical heel stitches, I used Eye of Partridge stitch, which gives the same sturdy fabric but is more ornamental.

You can easily make these socks longer by adding an extra 16-row repeat of the charted pattern or just some plain rows before beginning the toe shaping. Get an extra skein for a woman's shoe larger than a size U.S. 7.

When you work on the double-pointed needles, use the yarn end from your cast-on to mark the beginning of the round. A locking marker can also be used if desired.

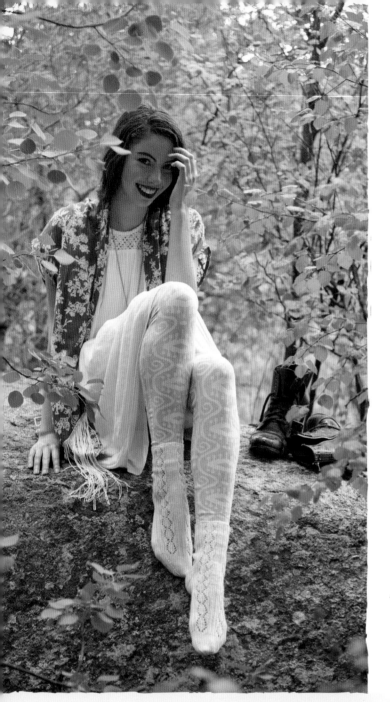

DIRECTIONS

CO 68 sts loosely but evenly, using the long-tail method (see Techniques). Distribute sts evenly over 4 dpn with 17 sts on each needle. Use yarn end or place marker (pm) for beg of rnd, and join for working in rnds, being careful not to twist sts.

Rnds 1 and 2: [P1, k2, (p1, k4) twice, p1, k2, p1] across each needle.

Work chart Rows 1–14 five times, or until leg is desired length to top of heel, ending with Rnd 14.

Using Needle 4, p1 from Needle 1 and leave it on Needle 4, moving beg-of-rnd 1 st to left.

Heel Flap (Eye of Partridge)
Row 1: (RS) Using one dpn, *sl 1 pwise wyb, k1; rep from * across Needles 1 and 2 to last st on Needle 2, sl last st to Needle 3—32 sts on needle for heel. Cont working back and forth on these sts for heel flap and leave rem 36 sts on Needles 3 and 4 for instep.

Row 2: (WS) Sl 1 kwise wyf, purl to end.

Row 3: Sl pwise wyb, k2, *sl 1 pwise wyb, k1; rep from * to last st, k1.

Row 4: Rep Row 2.

Row 5: *Sl 1 pwise wyb, k1; rep from * to end.

Rep Rows 2–5 six times, then rep Rows 2–4 once more. There should be 16 slipped sts along each edge of heel flap.

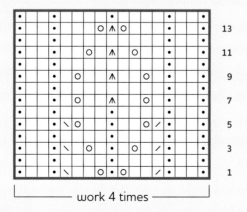

— work 4 times —

	knit
•	purl
o	yo
/	k2tog
\	ssk
ʌ	s2kp (see Techniques)
	pattern repeat

Turn Heel

Row 1: (RS) Sl 1 pwise wyb, k16, k2tog, sl 1, wrap and turn (see Stitch Guide).

Row 2: (WS) P3, p2tog, sl 1, w&t.

Row 3: K4, k2tog, sl 1, w&t.

Row 4: P5, p2tog, sl 1, w&t.

Row 5: K6, k2tog, sl 1, w&t.

Row 6: P7, p2tog, sl 1, w&t.

Row 7: K8, k2tog, sl 1, w&t.

Row 8: P9, p2tog, sl 1, w&t.

Row 9: K10, k2tog, sl 1, w&t.

Row 10: P11, p2tog, sl 1, w&t.

Row 11: K12, k2tog, sl 1, w&t.

Row 12: P13, p2tog, sl 1, w&t.

Row 13: K14, k2tog, sl 1, w&t.

Row 14: P15, p2tog, sl 1, w&t.

Row 15: K17—18 sts rem.

Gusset

With RS facing, Needle 1, pick up and knit 1 st in gap at top of heel flap, then 16 sts along side of heel flap; Needle 3, p1, work next row of chart as established; Needle 4, work chart patt as established to last st, p1; with a new dpn, pick up and knit 16 sts along rem side of heel flap, then 1 st in gap at top of heel flap, k9 from Needle 1—88 sts. Renumber needles with 26 sts for each on Needles 1 and 4 for heel and gussets, and 18 sts each on Needles 2 and 3 for instep. Pm for beg of rnd and cont working in rnds. Rnds beg at center under foot.

Rnd 1: Needles 1, knit; Needles 2 and 3, work in established patt; Needle 4, knit.

Rnd 2: Needle 1, knit to last 3 sts, k2tog, k1; Needles 2 and 3, work in established patt; Needle 4, k1, ssk, knit to end—2 sts dec'd.

Rep last 2 rnds 9 more times, then rep Rnd 1 again—68 sts rem; 16 sts each on Needles 1 and 4, and 18 sts each on Needles 2 and 3.

Move first st on Needle 2 to Needle 1, and last st on Needle 3 to Needle 4—17 sts on each needle.

Foot

Cont in established patts until foot is 2" (5 cm) shorter than desired length, ending with Row 15 of chart. If needed, add a few rnds of St st worked over all sts to get correct foot length.

Toe

Rnd 1: (dec) Needle 1, knit to last 3 sts, k2tog, k1; Needle 2, k1, ssk, knit to end; Needle 3, knit to last 3 sts, k2tog, k1; Needle 4, k1, ssk, knit to end—4 sts dec'd.

Rnd 2: Knit.

Rep Rnds 1 and 2 eight more times—32 sts rem, with 8 sts on each needle.

Rep Rnd 1 six times—8 sts rem, with 2 on each needle.

Cut yarn leaving a 9" (23 cm) tail, thread tail through rem sts twice, pull tight to close hole, and fasten off on WS. Alternatively, graft rem 8 sts tog using Kitchener st (see Techniques).

Make second sock same as first.

FINISHING

Weave in ends. Soak in cool water until fully saturated (about 30 minutes). Press to remove water, roll in a towel, and blot to remove extra water. Lay out to finished measurements and shape gently. If desired, insert sock blocker into each sock. Allow to dry completely.

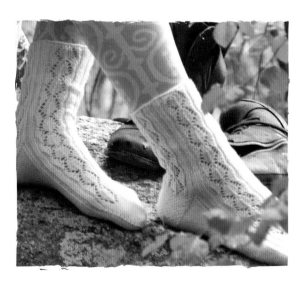

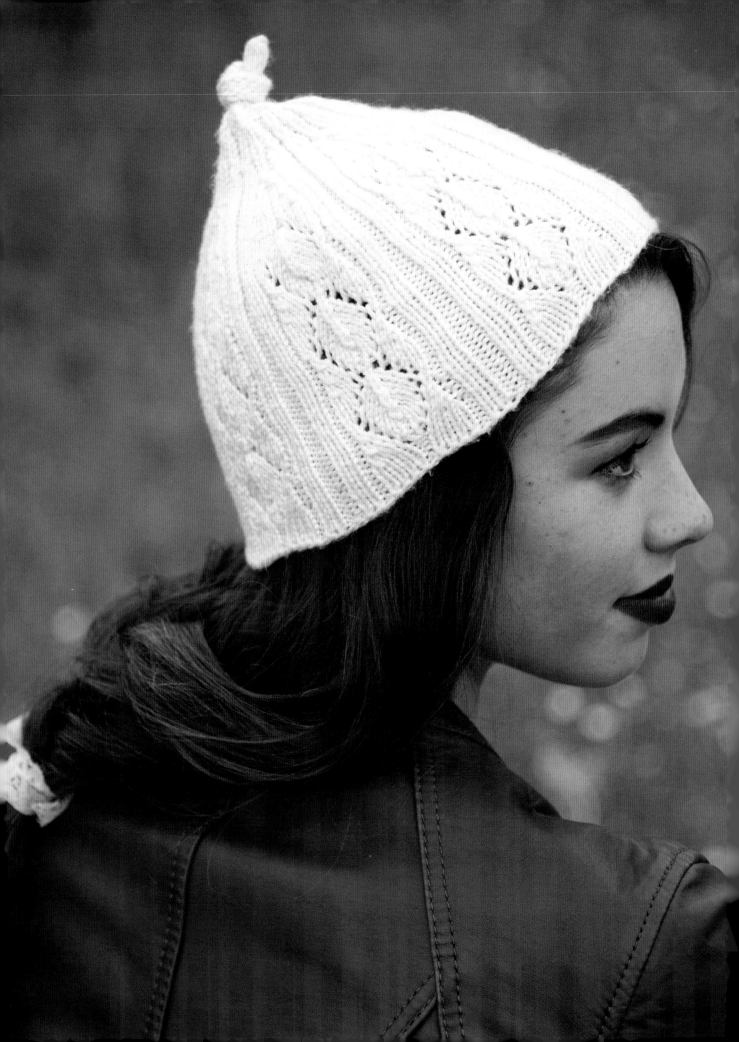

Mont Blanc
Chamonix Beanie

This hat matches the Chamonix Lace Socks. For this piece I replaced the fine-weight yarn used for the socks with a DK weight yarn in the same fiber blend. I also replaced the yarnovers used in the sock pattern to M1s, which have the same look but make a smaller hole. The better to keep your head warm!

FINISHED SIZE

16½" (42 cm) circumference and 8¼" (21 cm) tall.

YARN

DK weight (#3 Light).

Shown here: Crystal Palace Panda Pearl (53% bamboo, 42% merino, 5% silk; 220 yd [201 m]/100 g): #7204 Natural, 1 skein.

NEEDLES

Size U.S. 4 (3.5 mm): 16" (40 cm) circular (cir), and set of 5 double-pointed (dpn). *Adjust needle size if necessary to obtain the correct gauge.*

NOTIONS

Marker (m); locking marker (m) (optional); tapestry needle.

GAUGE

29 sts and 36 sts = 4" (10 cm) over chart patt, blocked.

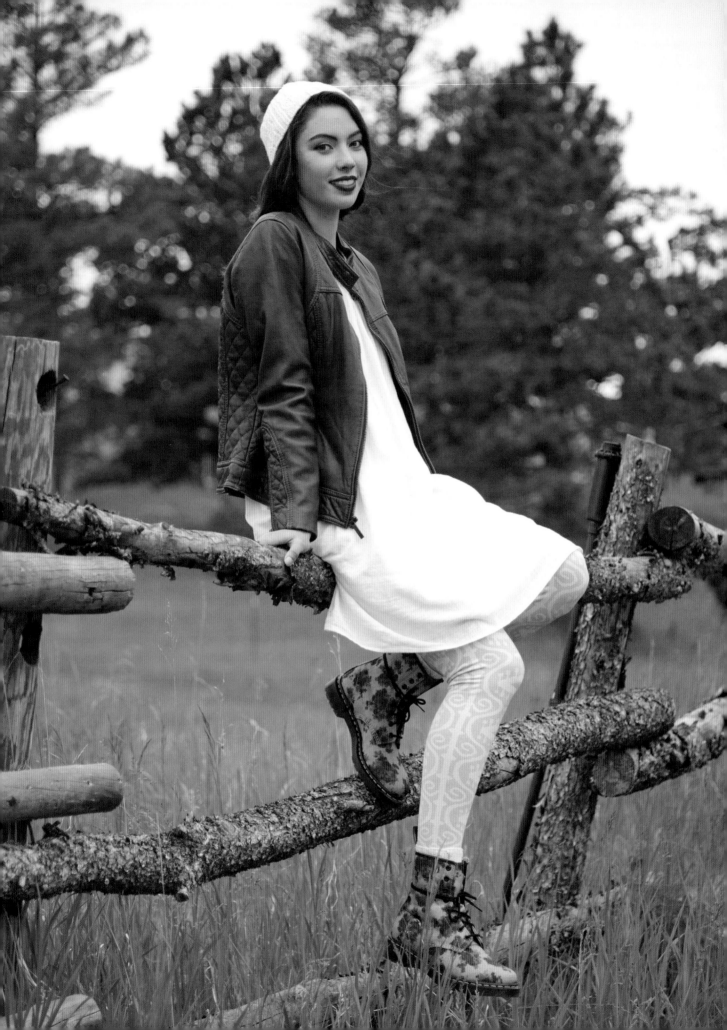

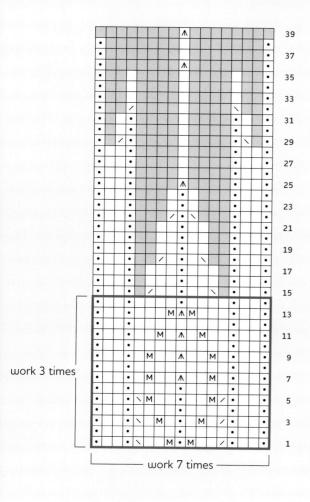

work 3 times

work 7 times

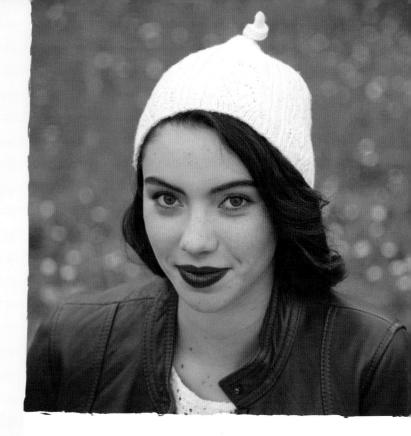

Key

Symbol	Meaning
(blank)	knit
•	purl
M	make 1 by lifting horizontal bar from row below and knit without twisting
/	k2tog
\	ssk
⋀	s2kp (see Techniques)
(shaded)	no stitch
(outline)	pattern repeat

DIRECTIONS

With cir needle, CO 119 sts loosely but evenly using long-tail method (see Techniques). Place marker (pm) for beg of rnd, and join for working in rnds, being careful not to twist sts.

Rnds 1–6: *P1, k2, (p1, k4) twice, p1, k2, p1; rep from * 6 more times around.

Work chart Rows 1–14 three times.

Shape Top

Work chart Rows 15–39—7 sts rem. Change to dpn when there are too few sts to work comfortably on cir needle, replacing marker with yarn end or locking marker if you choose.

Work I-cord (see Techniques) over rem 7 sts for 4" (10 cm).

Cut yarn leaving a 9" (23 cm) tail, thread tail through rem sts twice, pull tight to close hole, then fasten off on WS.

FINISHING

Weave in ends but do not trim. Soak in cool water until fully saturated (about 30 minutes). Press to remove water, roll in a towel, and blot to remove extra water. Lay out flat to dry, gently patting into shape, and allow to dry completely. Trim ends. Tie I-cord in an overhand knot.

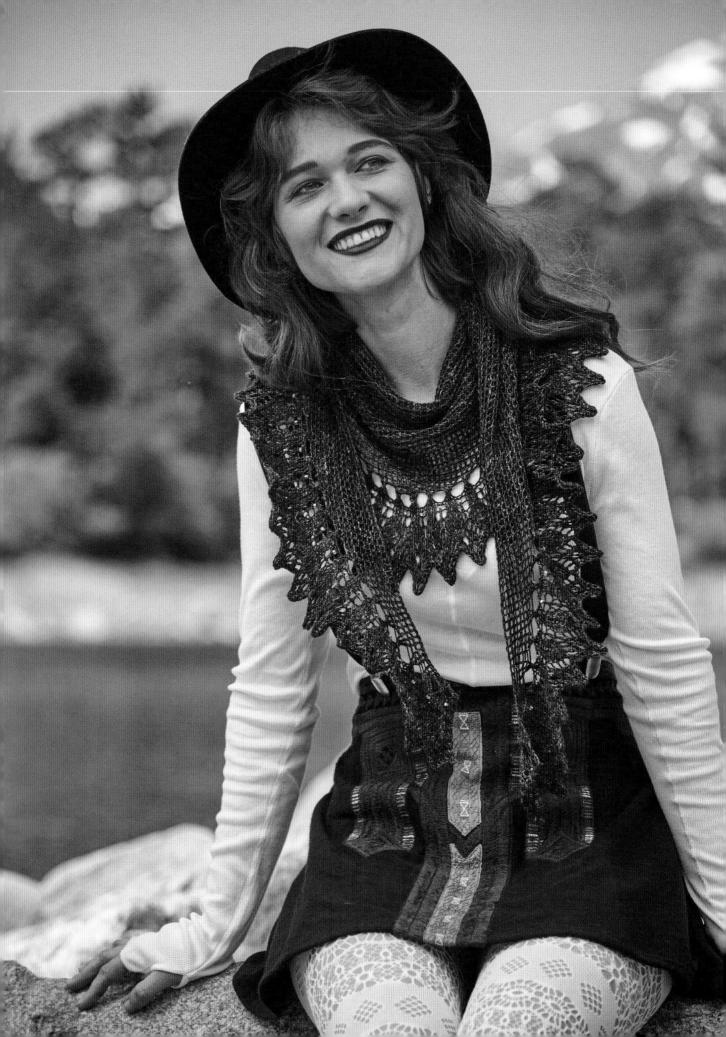

Mount Kosciuszko
Charlotte Pass Crescent Wrap

Mount Kosciuszko is the tallest peak in Australia, at 7,310 feet (2,228 m). You can drive in to Charlotte Pass and then hike eight miles to the summit. It is snow-covered in winter and spring, and you can cross-country ski in when there is good snow!

Some argue that the tallest peak on the continent is this one, but if you really consider the whole "continent" of Oceania, then it most certainly is not! This is one of the controversies that climbers and geologists continue to banter about.

FINISHED SIZE

52" (132 cm) wide and 12½" (31.5 cm) long at center, blocked and relaxed.

YARN

Light Fingering (#1 Super Fine).

Shown here: The Fibre Company Meadow (40% merino, 25% baby llama, 20% silk, 15% linen; 549 yd [498 m]/100 g): Pokeweed, 1 skein.

NEEDLES

Size U.S. 4 (3.5 mm): 40" (100 cm) circular (cir). *Adjust needle size if necessary to obtain the correct gauge.*

NOTIONS

78 size 6/0 Czech seed beads in crystal bronze-lined AB; size U.S. 14 (0.6 mm) steel crochet hook, or size to fit beads; markers (optional); tapestry needle; stainless T-pins; blocking mats; one 60" (152.5 cm) length of blocking wire.

GAUGE

18 sts and 34 rows = 4" (10 cm) over garter st, blocked and relaxed.

NOTES

A word about slipping selvedge stitches: Don't!

Beads: See Techniques.

For this project I chose to knit into the back loop of my stitches in the garter-stitch section. Consider this optional, but it adds a little something special to the finished look.

STITCH GUIDE
Cluster 3: [K3tog, yo, k3tog] in same 3 sts.

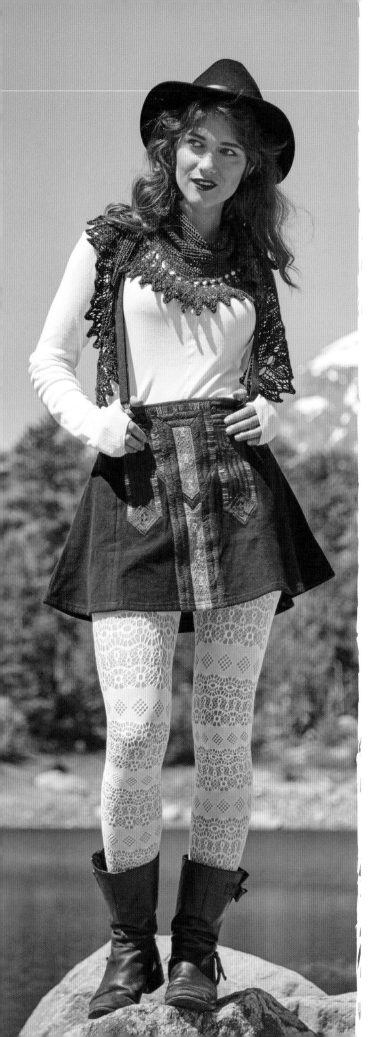

DIRECTIONS

CO 237 sts using long-tail method (see Techniques).

Short-row 1: Knit to last 3 sts, working in back of loop of each st if desired (see Notes), turn.

Short-row 2: Sl 1 pwise wyb, knit to last 3 sts, turn.

Short-row 3: Sl 1 pwise wyb, knit to 3 sts before last turn, turn.

Rep last short-row 75 more times—3 sts rem in work at center of row. Cut yarn leaving a 9" (23 cm) tail.

Slip sts from right needle tip to left needle tip. Rejoin yarn at edge and knit 1 row over all sts.

Next row: *Cluster 3 (see Stitch Guide), yo; rep from * to last 3 sts, Cluster 3—315 sts, with 79 clusters.

Next row: K3, purl to last 3 sts, k3.

Next row: (RS) Working Row 1 of chart, beg at right edge of chart, work 7 sts, 4-st rep 76 times, then 4 sts at left edge of chart.

Next row: (WS) Working Row 2 of chart, beg at left edge of chart, work 4 sts, 4-st rep 76 times, then 7 sts at right edge of chart.

Work Rows 3–14 as established—931 sts.

BO row: K2, return 2 sts just worked to left needle tip, k2togtbl, *k1, return 2 sts just worked to left needle tip, k2togtbl; rep from *. Cut yarn leaving a 9" (23 cm) tail, pull tail through rem st.

FINISHING

Weave in ends but do not trim. Soak in cool water until fully saturated (about 30 minutes). Press to remove water, roll in a towel, and blot to remove extra water.

Weave blocking wire through CO edge and pin piece out in a gentle curve to schematic measurements, pulling each point along bottom edge down firmly. Allow to dry completely. Wrap will relax to finished measurements after removing pins. Trim ends.

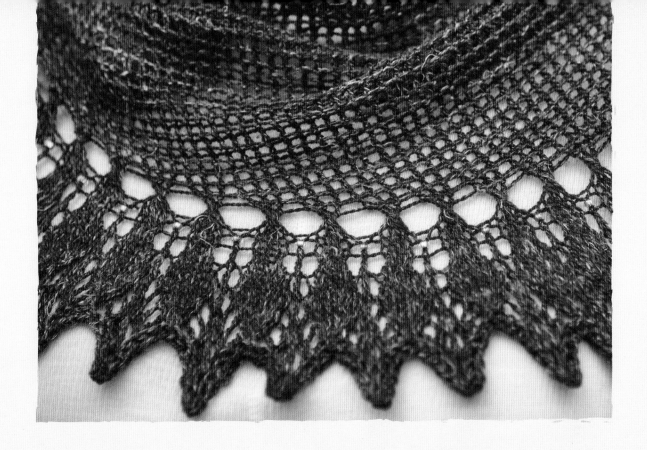

Symbol	Meaning
☐	k on RS, p on WS
•	p on RS, k on WS
ℛ	k1tbl on RS, p1tbl on WS
o	yo
∕	k2tog
∖	ssk
⋀	s2kp (see Techniques)
⅋	k1f&b (see Techniques)
⅃	(k1, yo, k1) in same st
▬	place bead (see Techniques)
▨	no stitch
☐	pattern repeat

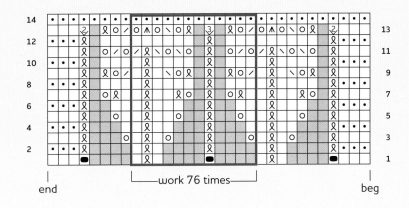

—work 76 times—

end beg

60"
152.5 cm

16"
40.5 cm

Chapter 5

PROJECTS 2: THE SEVEN SUMMITS

The seven summits represent the tallest peak on each of the seven continents. The following projects each represent a mountain and are presented from lowest to highest, although the technical challenge of both the climbs and the knitting are not necessarily based on the height. Enjoy!

© iStockphoto.com/Torsakarin

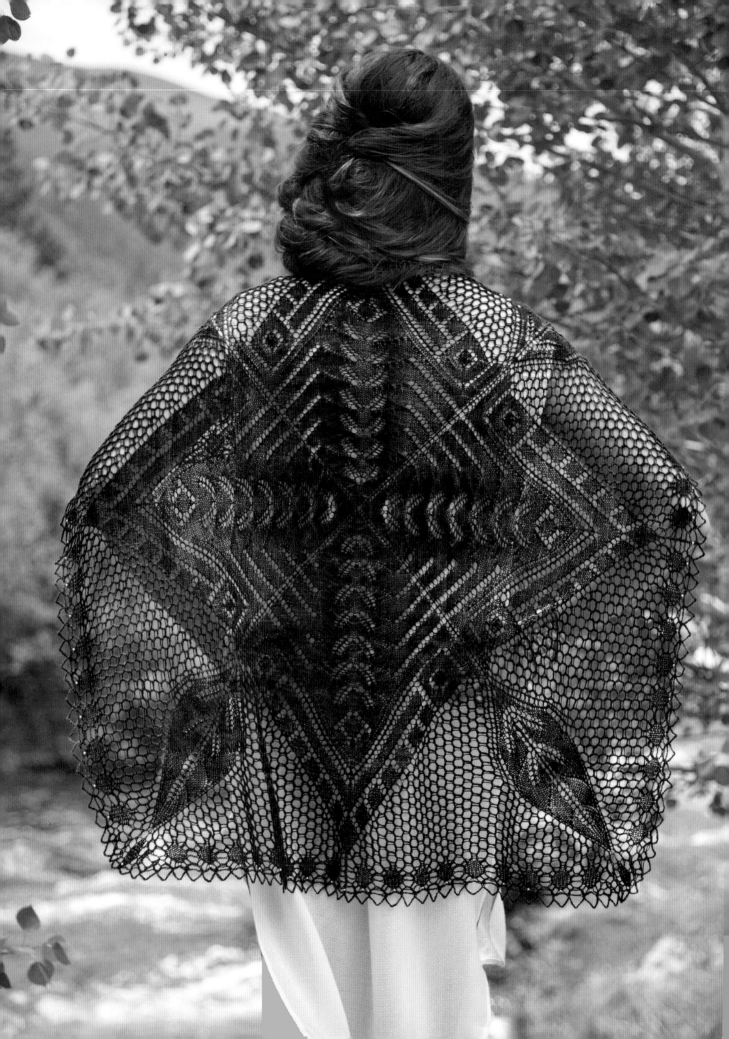

Australia/Oceania: Puncák Jaya

Oceania Shawl or Throw

At 16,024 feet (4,884 m), the Carstensz Pyramid is the tallest mountain in Indonesia and on the Australian "continent" of Oceania. The first documented summit success was in 1962 by an Austrian expedition. Although known as the Carstensz Pyramid, possibly as long ago as 1623 when it was first spotted on an unusually clear day, the name was changed to Puncák Jaya in the latter half of the 1900s. Puncák means "peak" and Jaya means "glorious." Carstensz Pyramid is still the name used among mountain climbers.

FINISHED SIZE

32" (81.5 cm) along each edge, square, and 36" (91.5 cm) wide at center.

YARN

Laceweight (#0 Lace).

Shown here: Tess' Designer Yarns Superwash Merino Lace (100% superwash merino; 500 yd [457 m]/50 g): Cobalt Blue, 2 skeins.

NEEDLES

Size U.S. 2 (2.75 mm): set of 5 double-pointed (dpn), 24" (60 cm), and 40" (100 cm) circular (cir). *Adjust needle size if necessary to obtain the correct gauge.*

NOTIONS

200 size 8/0 Japanese seed beads in opaque cobalt luster; 80 Duracoat 8/0 seed beads in gold; size U.S. 14 (0.6 mm) steel crochet hook or size to fit beads; size U.S. 0 (1.75 mm) steel crochet hook for crochet bind-off; marker (m); locking markers (m) (optional); tapestry needle; stainless T-pins; blocking mats; four 60" (152.5 cm) long lengths of flexible blocking wire.

GAUGE

28 sts = 4" (10 cm) over St st, blocked and relaxed.

NOTES

Beads: See Techniques. Use the gold beads on Round 169 only; use the cobalt beads on all other rounds.

On odd-numbered rounds, beginning with Round 125, each round/repeat begins and ends with a double yarnover. See Techniques.

Gathered Crochet Bind-Off: See Techniques

Nupps: See Techniques

When you work on the double-pointed needles, use the yarn end from your cast-on to mark the beginning of the round. A locking marker can also be used if desired.

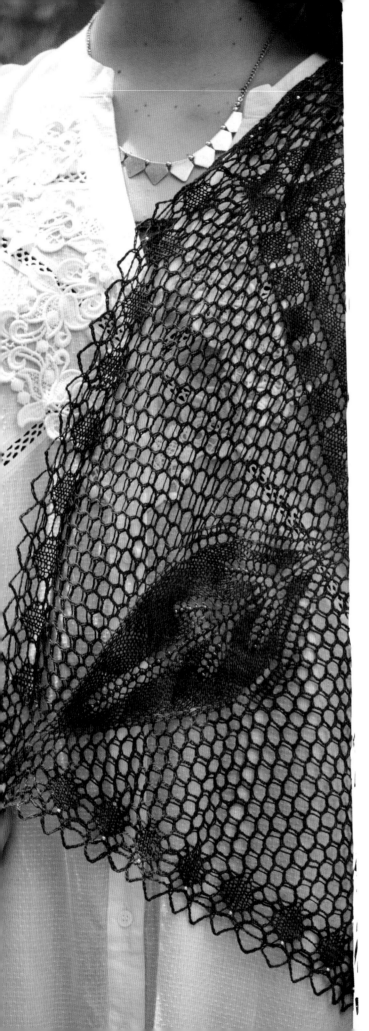

DIRECTIONS

With dpn, CO 8 sts using long-tail method (see Techniques). Divide sts evenly over 4 dpn with 2 sts on each needle. Use yarn end or place locking marker (pm) for beg of rnd, and join for working in rnds, being careful not to twist sts.

Next rnd: [K1tbl] around.

Rnd 1: Work Row 1 of chart A as foll: *[k1tbl, M1] twice, pm; rep from * around—8 sts inc'd.

Work Rows 2–84 as established—344 sts. Change to short cir needle when there are too many sts to work comfortably on dpn. Change to long cir needle as number of sts increases.

Work Rows 85–156 of chart B—624 sts.

Work Rows 157–168 of Border chart—680 sts.

With larger crochet hook, BO as foll: *[Gather 4 sts (see Stitch Guide), ch 7] 9 times, gather 4, ch 4, gather 2, ch 5, gather 3, ch 5, gather 2, ch 4, [gather 4, ch 7] 20 times, gather 3, ch 7, [gather 4, ch 7] 10 times; rep from * 3 more times, sl st in first group of sts at beg of rnd. Cut yarn leaving a 9" (23 cm) tail, pull tail through rem st.

FINISHING

Weave in ends but do not trim. Soak in cool water until fully saturated (about 30 minutes). Press to remove water, roll in a towel, and blot to remove extra water.

Weave one long blocking wire through crochet loops along each edge, pin wires out to schematic measurements, creating a slightly rounded square. Allow to dry completely before removing pins and wires. Shawl will relax to finished measurements after removing pins. Trim ends.

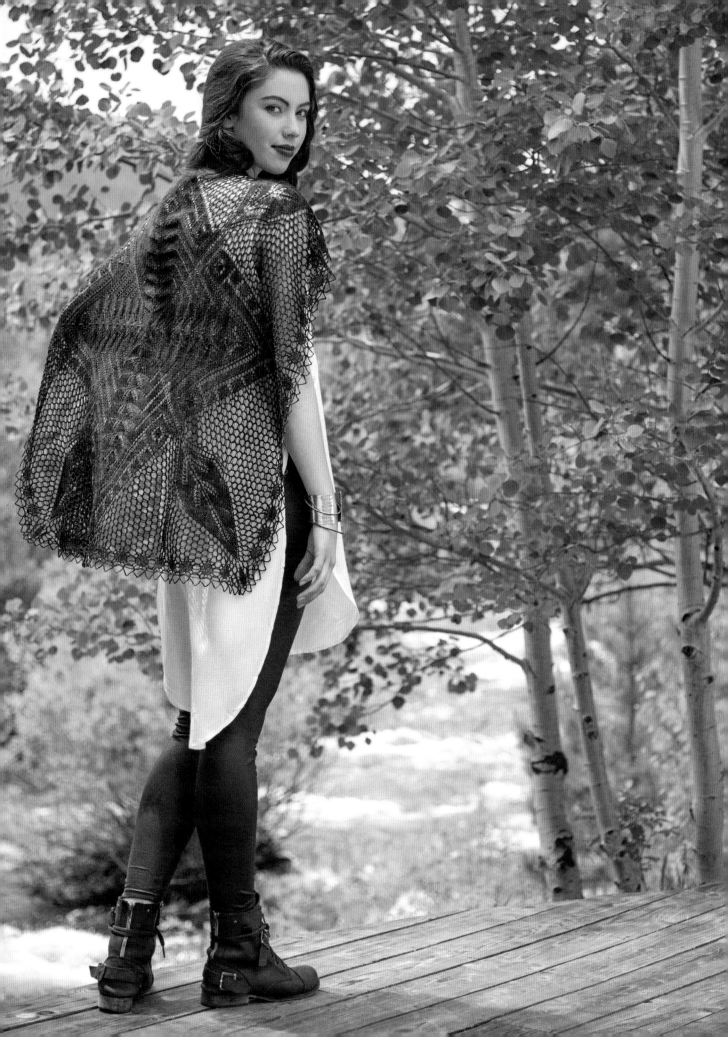

— work 4 times —

*Note: Stitches shaded purple are duplicated for ease of following
the two halves of the chart; work the shaded stitches only once.*

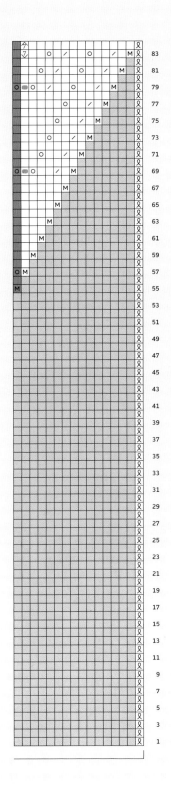

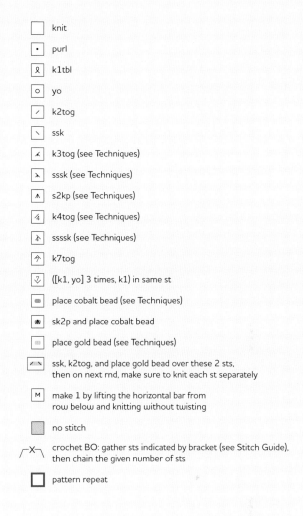

knit

• purl

k1tbl

○ yo

╱ k2tog

╲ ssk

k3tog (see Techniques)

sssk (see Techniques)

s2kp (see Techniques)

k4tog (see Techniques)

ssssk (see Techniques)

k7tog

([k1, yo] 3 times, k1) in same st

place cobalt bead (see Techniques)

sk2p and place cobalt bead

place gold bead (see Techniques)

ssk, k2tog, and place gold bead over these 2 sts, then on next rnd, make sure to knit each st separately

M make 1 by lifting the horizontal bar from row below and knitting without twisting

no stitch

crochet BO: gather sts indicated by bracket (see Stitch Guide), then chain the given number of sts

pattern repeat

40"
101.5 cm

40"
101.5 cm

— work 4 times –

Note: Stitches shaded purple are duplicated for ease of following the two halves of the chart; work the shaded stitches only once.

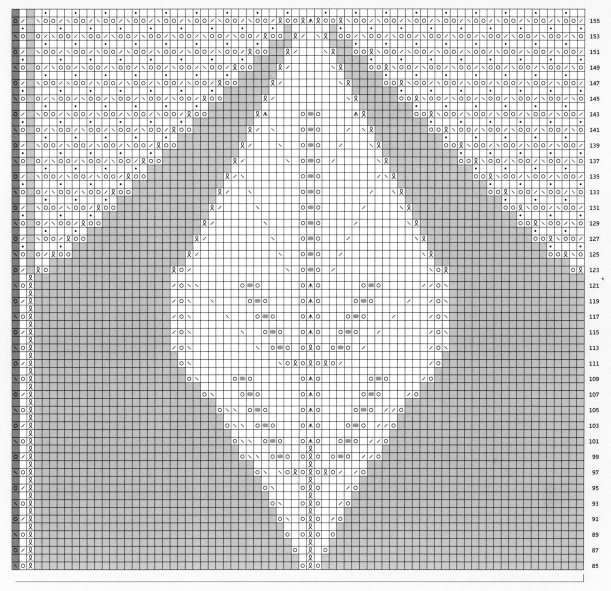

155
153
151
149
147
145
143
141
139
137
135
133
131
129
127
125
123
*
121
119
117
115
113
111
109
107
105
103
101
99
97
95
93
91
89
87
85

*End rnd 122 one st before end of rnd, sl 1,
remove beg-of-rnd m, sl 1 back to left needle tip,
replace beg-of-rnd m.

Border chart

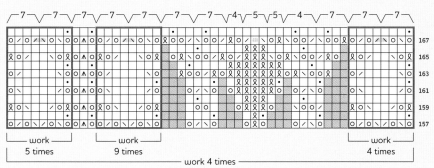

167
165
163
161
159
157

work
5 times

work
9 times

work
4 times

work 4 times

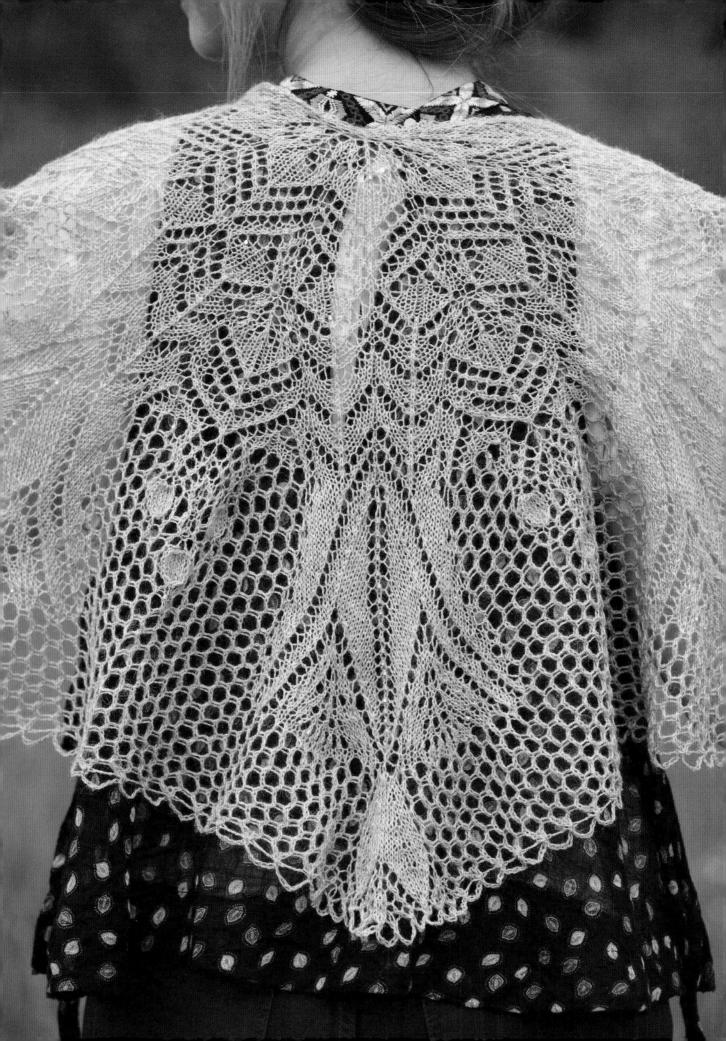

Antarctica: Vinson Massif

Diamond Dust Wrap

Diamond dust is a ground-level "cloud" composed of crystals of ice. Also called ice crystals, diamond dust generally forms under clear skies. It is most commonly seen in Antarctica, and this type of precipitation may continue for several days without interruption.

A massif is a section of the earth's crust that is marked by faults. When the crust moves, a massif retains its internal structure while being moved as a whole. The term is used to refer to a group of mountains formed in this way.

Mount Vinson is the highest peak in Antarctica, at 16,050 feet (4,892 m). The massif is about 750 miles (1,200 km) from the South Pole and is about 13 miles (21 km) long and 8.1 miles (13 km) wide. It was named after Carl Vinson, a U.S. congressman from Georgia. The Vinson Massif was first seen in 1958 and first climbed in 1966. As of February 2010, 1,400 climbers have attempted to reach the top of Mount Vinson.

This piece combines classic hex-mesh and leaves, along with stylized ice floats and sea creatures. It is a full circle/hexagon with an opening that wraps around the wearer like a cloak.

FINISHED SIZE
40½" (103 cm) wide and 16½" (42 cm) long at center back, blocked and relaxed.

YARN
Laceweight (#0 lace).

Shown here: Cascade Alpaca Lace (100% baby alpaca; 437 yd [400 m]/ 50 g): #1413 Silver, 2 skeins.

NEEDLES
Size U.S. 2 (2.75 mm): 40" (100 cm) circular (cir). *Adjust needle size if necessary to obtain the correct gauge.*

NOTIONS
Smooth waste yarn; 25 g Toho 8/0 Japanese seed beads in silver-lined matte crystal AB with square holes #TB-F635; size U.S. 14 (0.6 mm) steel crochet hook, or size to fit beads;

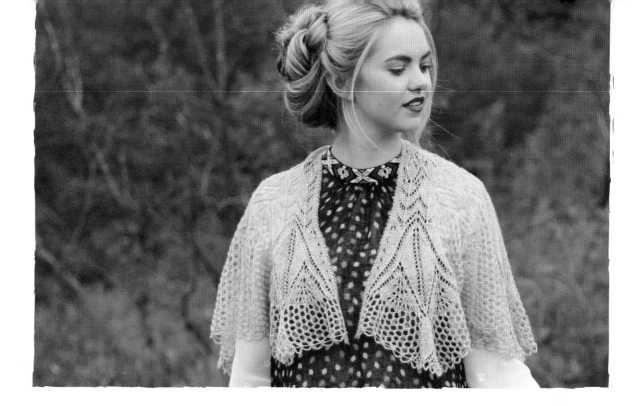

size U.S. 0 (1.75 mm) steel crochet hook for bind-off; markers (optional); tapestry needle; stainless T-pins; blocking mats; four 60" (152.5 cm) lengths of blocking wire.

GAUGE

32 sts and 28 rows = 4" (10 cm) over St st, blocked and relaxed.

NOTES

Beads: See Techniques.

Gathered Crochet Bind-Off: See Techniques

A word about slipping selvedge stitches: Don't! This piece was designed to block freely and slipped selvedge stitches will create a less flexible edge.

DIRECTIONS

With waste yarn, CO 3 sts.

Knit 13 rows.

Next row: K3, do not turn, but rotate piece 90 degrees to right, then pick up and purl 6 sts along left side edge (1 st in each garter ridge). Turn work another 90 degrees right and pick up and knit 3 sts in provisional CO, removing waste yarn—12 sts. Turn work.

Next row: (RS) Working chart A, beg at right edge of Row 1, k3, (k1tbl, yo) 5 times, k1tbl, k3—17 sts.

Next row: Beg row 2 at left edge of chart, k3, p1tbl (k1, p1tbl) 5 times, k3.

Work Rows 3–34 of chart A as established—149 sts.

Work Rows 35–68 of chart B—269 sts.

Work Rows 69–78 of chart C—379 sts.

Work Rows 79–90 of chart D—457 sts.

Work Rows 91–112 of chart E—484 sts.

Work Rows 113–138 of chart F—688 sts.

BO row: (RS) Gather 3, ch 7, *[gather 4, ch 7] 6 times, [gather 3, ch 7] 13 times, [gather 4, ch 7] 14 times; rep from * 4 more times, [gather 4, ch 7] 6 times, [gather 3, ch 7] 13 times, [gather 4, ch 7] 6 times, gather 3, pulling yarn through all loops on hook, ch 1. Cut yarn leaving a 9" (23 cm) tail, pull tail through rem st.

FINISHING

Weave in ends but do not trim. Soak in cool water until fully saturated (about 30 minutes). Press to remove water, roll in a towel, and blot to remove extra water.

Weave one long blocking wire along top edge, and 3 more long blocking wires through crochet loops along bottom edge. Pin shawl out to schematic measurements. Allow to dry completely. Shawl will relax to finished measurements after removing pins. Trim ends.

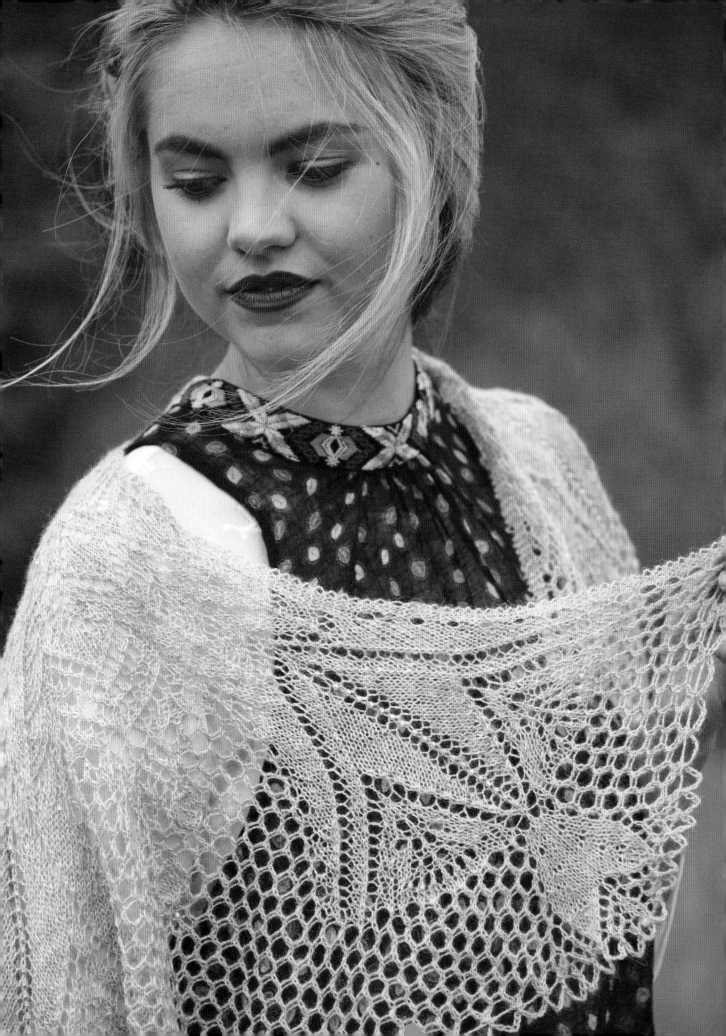

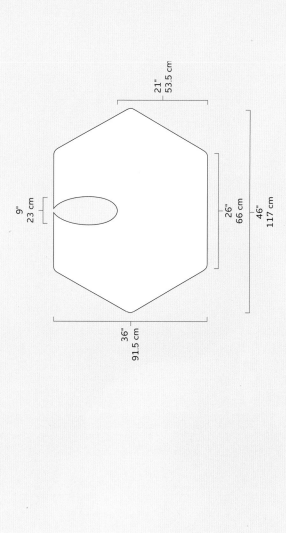

21"
53.5 cm

9"
23 cm

26"
66 cm

46"
117 cm

36"
91.5 cm

Chart A

33 31 29 27 25 23 21 19 17 15 13 11 9 7 5 3 1

beg

work 5 times

34 32 30 28 26 24 22 20 18 16 14 12 10 8 6 4 2

end

	k on RS, p on WS
	p on RS, k on WS
	k1tbl
	yo
	k2tog
	ssk
	s2kp
	k3tog (see Techniques)
	sssk (see Techniques)
	pick up strand between sts and (k1, yo, k1) into loop without twisting
	knit into front, back, then front of same st
	[(k1, p1) 3 times, k1] in same st
	sssk, k4tog, psso
	place bead (see Techniques)
M	make 1 by lifting horizontal bar from row below and knit without twisting
	crochet BO: gather sts indicated by bracket (see Stitch Guide), then chain the given number of sts
	no stitch
	pattern repeat

82

Chart B

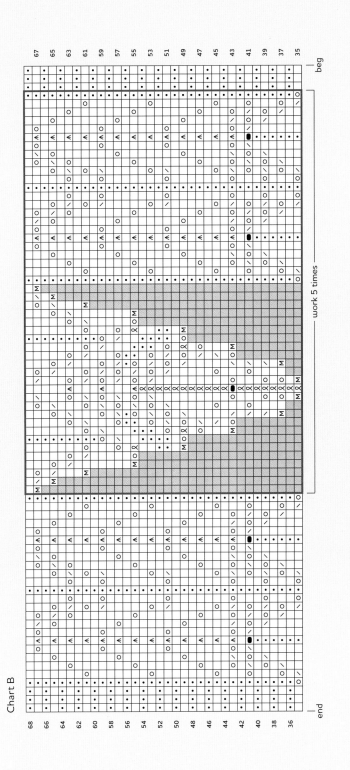

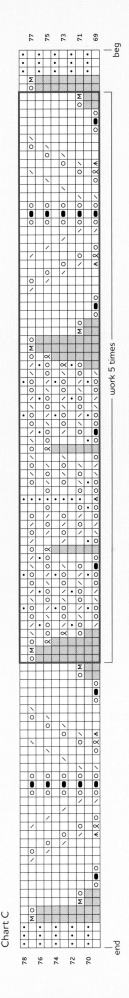

Chart D

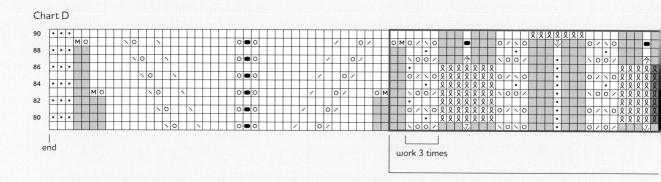

end

work 3 times

Chart E

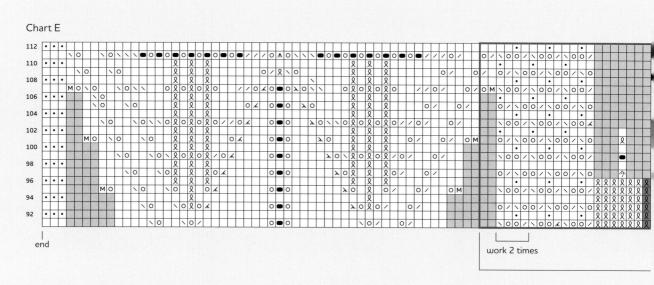

end

work 2 times

Chart F

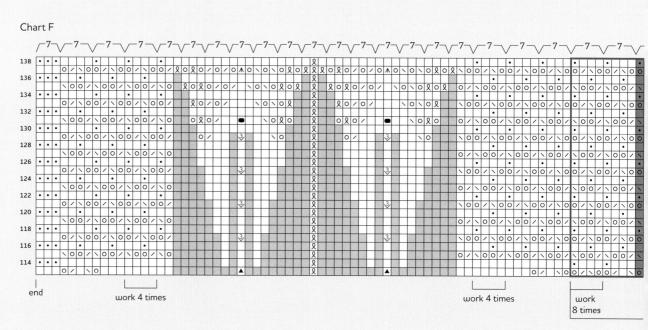

end

work 4 times

work 4 times

work
8 times

Note: Stitches shaded purple are duplicated for ease of following
the two halves of the chart; work the shaded stitches only once.

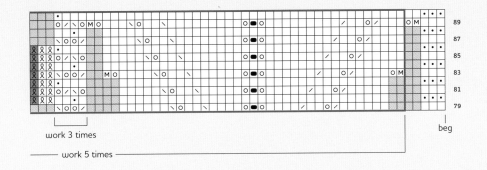

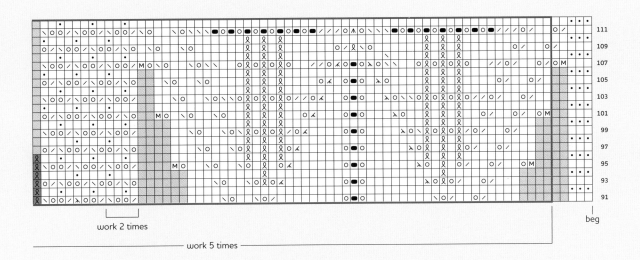

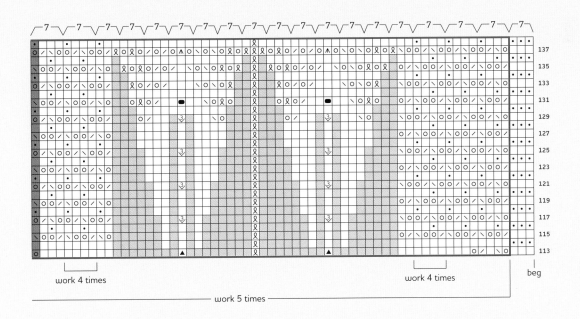

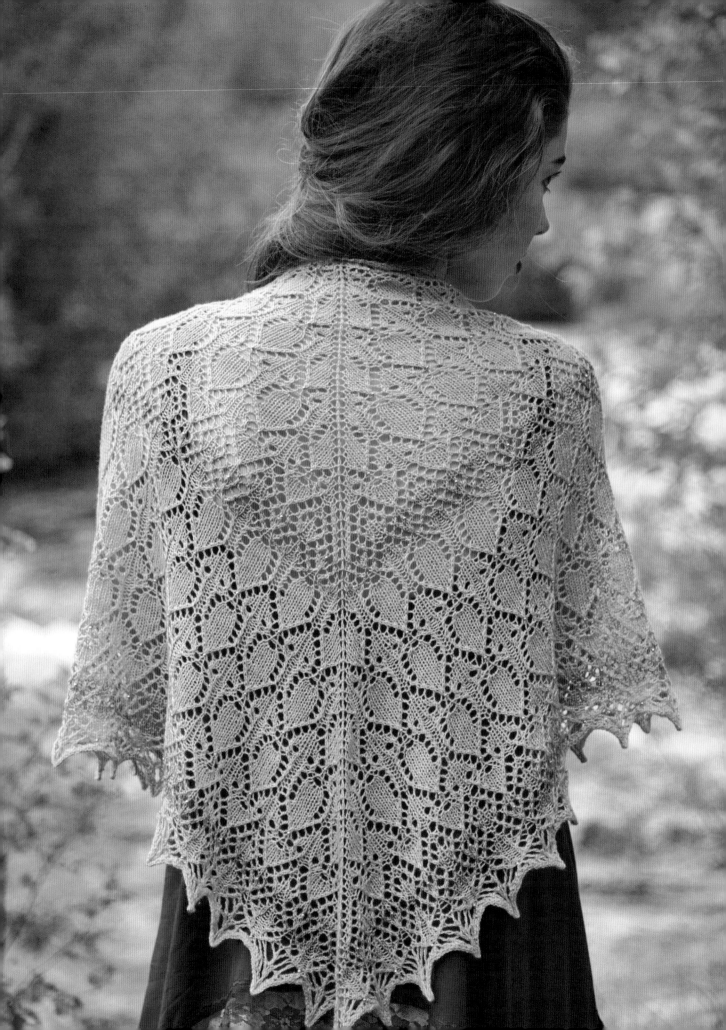

Europe: Mount Elbrus

Persian Sunrise Shawl

Although experts disagree about exactly how the Caucasus mountain range is shared between Europe and Asia, most agree that Mount Elbrus is the highest mountain on the European continent, at 18,602 feet (5,670 m). The first documented ascent was in 1874. Named after a mountain in Persian mythology, it is a dormant volcano, last active about A.D. 100.

This piece is a triangle with totally interchangeable motifs. You can use chart A, Rows 13–32 and chart B at will, and one will flow from the other any way you choose to use them. You can also make this piece as large as you like, adding extra repeats of chart A, Rows 13–32 and/or chart B, Rows 1–20, limited only by your yarn supply. Chart C will flow from either chart A or chart B. If you enjoy thinking about the triangle in a modular way, try some of the ideas in the final chapter! Directions are given for two versions of this project, but feel free to mix and match the charts.

FINISHED SIZE
56½" (143.5 cm) wide and 27" (68.5 cm) long.

YARN
Laceweight (#0 Lace).

Shown here: SweetGeorgia Merino Silk Lace (50% merino, 50% silk; 765 yd [700 m]/100 g): Saffron (yellow, A) and Dutch (orange, B), 1 skein each.

NEEDLES
Size U.S. 3 (3.25 mm): 40" (100 cm) circular (cir). *Adjust needle size if necessary to obtain the correct gauge.*

NOTIONS
Smooth waste yarn; 30 g Miyuki 8/0 Japanese seed beads in gold/galvanized; size U.S. 14 (0.6 mm) steel crochet hook; markers (optional); tapestry needle; stainless T-pins; blocking mats; one 60" (152.5 cm) length of blocking wire.

GAUGE
20 sts = 4" (10 cm) over St st, blocked and relaxed.

NOTES
Beads: See Techniques.

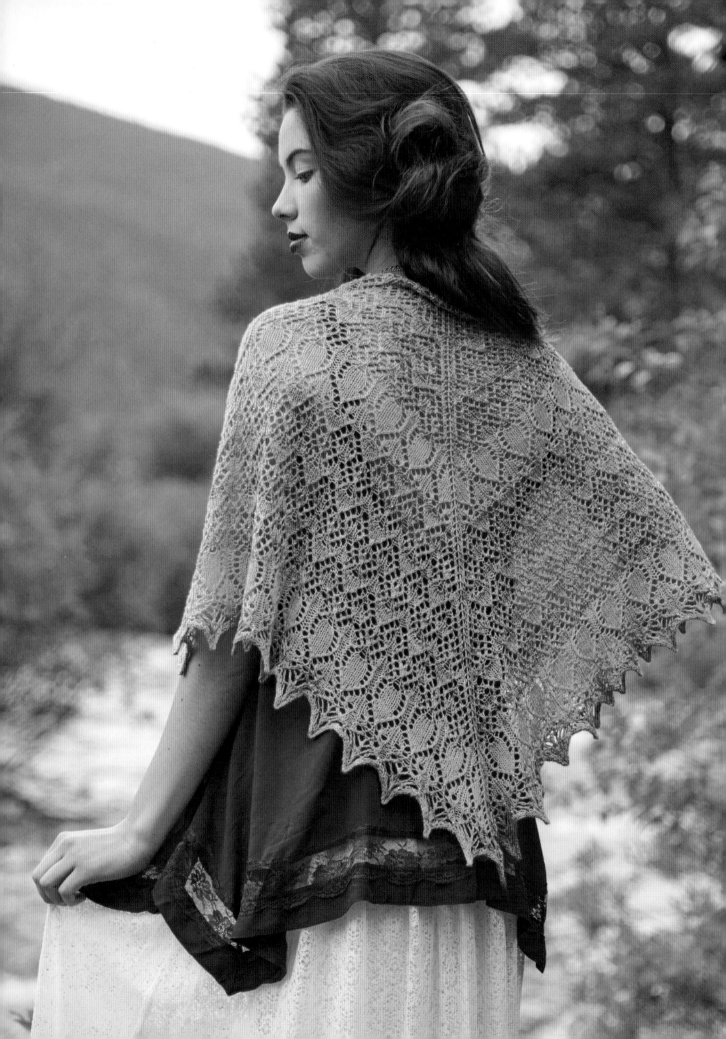

A word about slipping selvedge stitches: Don't! This piece was designed to block freely and slipped selvedge stitches will create a less flexible edge.

Directions are given for Version 1, with Version 2 in parentheses. Version 1 is worked primarily using chart A with color A (Saffron) with highlights in chart B with color B (Dutch). Version 2 is worked primarily using chart B with color B (Dutch) with highlights in chart A with color A (Saffron). The suggested yarn and beads will allow you to make both versions.

After working chart A (B) Rows 13–32 (1–20) for the first time, each additional time you repeat these rows, you will be working the 10-st repeat 2 more times in each half of the shawl.

DIRECTIONS

With color A (B), CO 3 sts using provisional method (see Techniques).

Knit 7 rows.

Next row: K3, do not turn, but rotate piece 90 degrees right, then pick up and purl 3 sts along the left-side edge (1 st in each garter ridge). Turn work another 90 degrees right and pick up and knit 3 sts in provisional CO, removing waste yarn—9 sts.

Turn work.

Row 1: (RS) Beg at right edge of chart A, work Row 1—4 sts inc'd.

Row 2: (WS) Beg at left edge of chart and work Row 2.

Work Rows 3–12 in established patt—33 sts.

Work Rows 13–32 (1–20) of chart A (B) 3 times—153 sts.

With color A for both versions, work Rows 1–10 (13–32) of chart B (A) once—173 (193) sts.

Version 1 only:
Change to color B. Work Rows 11–20 of chart B once—193 sts.

Both versions:
Change to A (B). Work Rows 13–32 (1–20) of chart A (B) 3 times—313 sts.

Version 1 only:
Work Rows 1–10 of chart B once—20 sts inc'd.

Change to B. Work Rows 11¬–20 of chart B once—353 sts.

Version 2 only:
Work Rows 13–32 of chart A once—353 sts.

Both versions:
With A (B), work Rows 1–10 of chart C once—441 sts.

With color A (B), work I-cord BO as foll:

Using knitted CO (see Techniques), CO 2 sts and place sts on left needle tip.

Next row: Pull yarn across back of work, k3, sl 3 sts just worked back to left needle tip.

Next row: Pull yarn across back of work, k2, k2tog, sl 3 sts just worked back to left needle tip.

Rep last 2 rows to last 3 sts.

Next row: K3togtbl. Cut yarn leaving a 9" (23 cm) tail, pull tail through rem st.

FINISHING

Weave in ends but do not trim. Soak in cool water until fully saturated (about 30 minutes). Press to remove water, roll in a towel, and blot to remove extra water.

Weave blocking wire through every vertical strand in garter st along top edge. Pin piece out to schematic measurements, pinning out each point, from inside the I-cord, so columns of sts are straight and even. Allow to dry completely. Shawl will relax to finished measurements after removing pins. Trim ends.

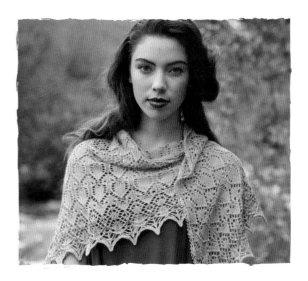

Chart A

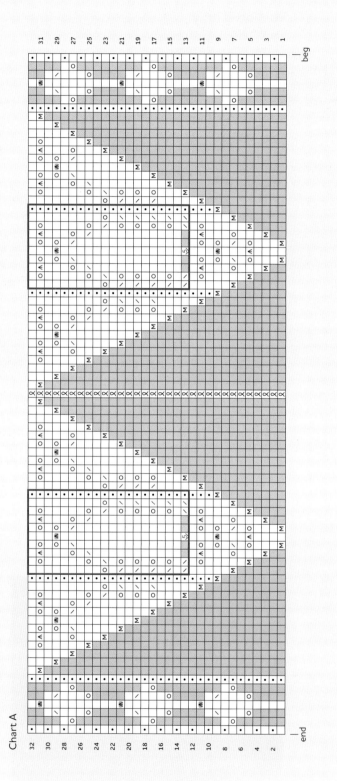

Chart B

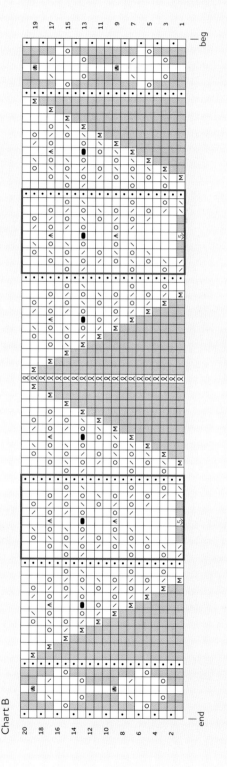

Chart C

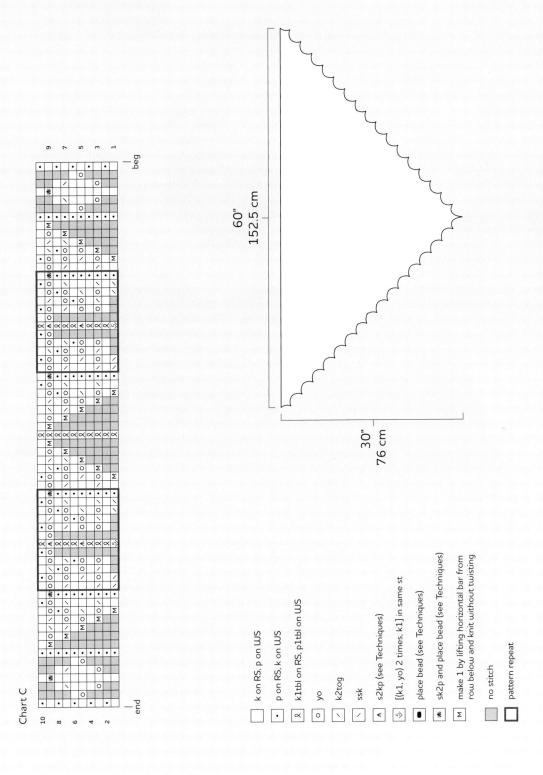

Key:

- k on RS, p on WS
- • p on RS, k on WS
- ⋉ k1tbl on RS, p1tbl on WS
- ○ yo
- ╲ k2tog
- ╱ ssk
- ⋀ s2kp (see Techniques)
- 5⟋ [(k1, yo) 2 times, k1] in same st
- ● place bead (see Techniques)
- ⋙ sk2p and place bead (see Techniques)
- M make 1 by lifting horizontal bar from row below and knit without twisting
- no stitch
- ▢ pattern repeat

60"
152.5 cm

30"
76 cm

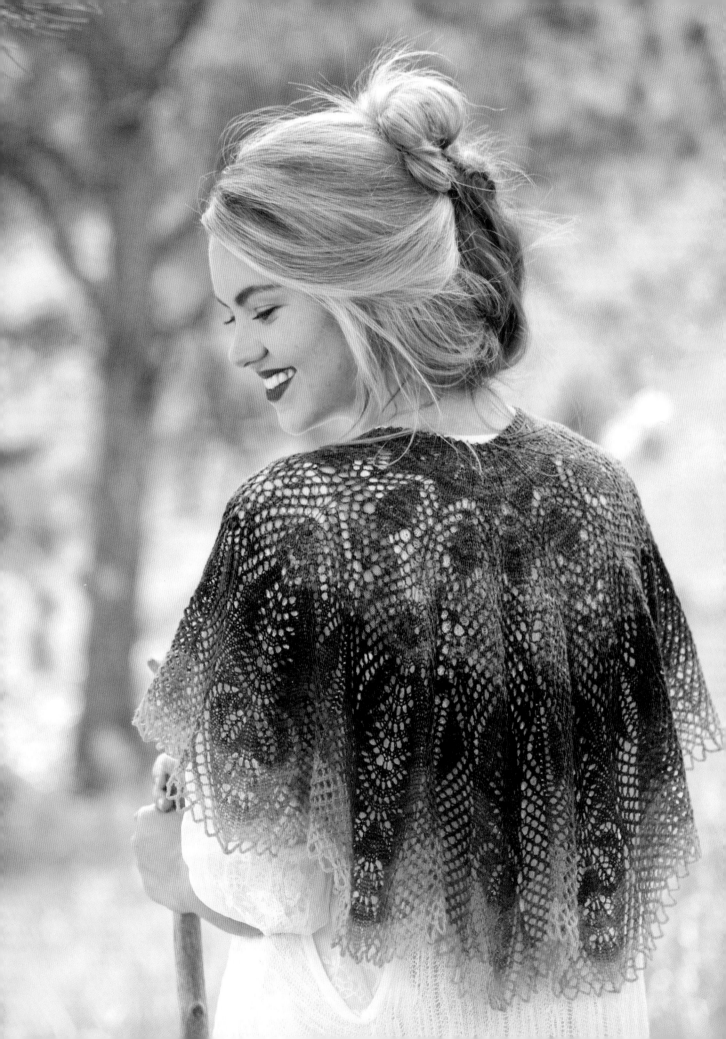

Africa: Mount Kilimanjaro

African Violet Shawl

Mount Kilimanjaro is the highest peak on the African continent. It has three dormant volcanic cones: Kibo, Mawenzi, and Shira. Located in Tanzania, it has the distinction of being the highest freestanding mountain in the world. Kibo is the highest of the peaks, at 19,341 feet (5,895 m) above sea level. The first documented ascent was in 1889. This project uses typical lace techniques along with beads and nupps. The patterning is evocative of both flora and fauna, with leaves, feathers, berries, flowers, and spiderwebs. This project is for the adventurous lace knitter.

FINISHED SIZE

35" (89 cm) wide and 17" (43 cm) long at center back.

YARN

Laceweight (#0 Lace).

Shown here: Knitwhits Freia Handpaints Ombre Lace (75% wool, 25% nylon; 645 yd [590 m]/ 75 g): Grapevine, 1 skein.

NEEDLES

Size U.S. 2 (2.75 mm): 40" (100 cm) circular (cir). *Adjust needle size if necessary to obtain the correct gauge.*

NOTIONS

Smooth waste yarn; 20 g Toho 8/0 Japanese seed beads in purple-lined rainbow rosaline #TB928; markers (optional); size U.S. 14 (0.6 mm) crochet hook, or size to fit beads; size U.S. 0 (1.75 mm) steel crochet hook for bind-off; tapestry needle; stainless T-pins; blocking mats; one 60" (152.5 cm) length of blocking wire.

GAUGE

24 sts = 4" (10 cm) over St st, blocked and relaxed. Please take time to check gauge so you do not run short of yarn.

NOTES

Beads: See Techniques.

A word about slipping selvedge stitches: Don't! This piece was designed to block freely and slipped selvedge stitches will create a less flexible edge

Gathered Crochet Bind-Off: See Techniques

Nupps: See Techniques

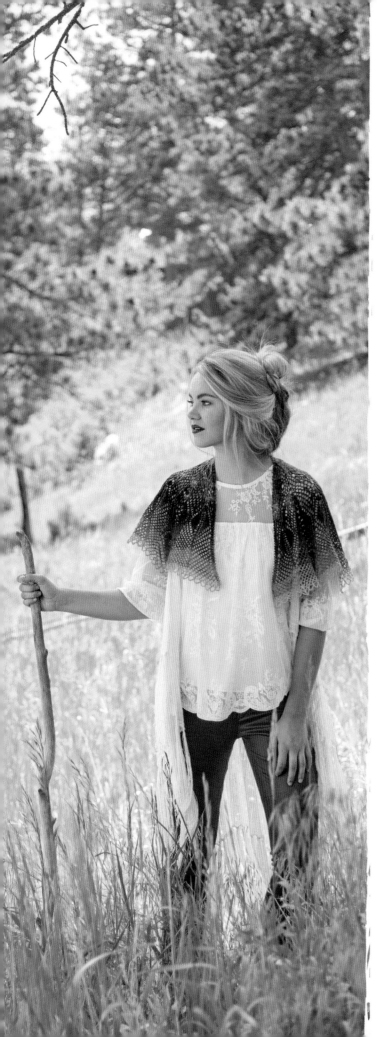

DIRECTIONS

CO 3 sts using provisional method (see Techniques).

Knit 17 rows.

Next row: K3, do not turn, but rotate piece 90 degrees right, then pick up and purl 8 sts along the side edge (1 st in each garter ridge), turn work another 90 degrees right and pick up and knit 3 sts in provisional CO, removing waste yarn—14 sts. Turn.

Row 1: (RS) Beg at right edge of chart A, work Row 1—9 sts inc'd.

Row 2: (WS) Beg at left edge of chart A, work Row 2.

Work Rows 3–32 in established patt—141 sts.

Work Rows 33–48 of chart B—271 sts.

Work Rows 49–88 of chart C—409 sts.

Work Rows 89–124 of chart D—573 sts.

BO row: (RS) With larger crochet hook, gather 3, [ch 6, gather 3, pulling yo through all loops on hook] to end. Cut yarn leaving a 9" (23 cm) tail, pull tail through rem st.

FINISHING

Weave in ends but do not trim. Soak in cool water until fully saturated (about 30 minutes). Press to remove water, roll in a towel, and blot to remove extra water.

Weave blocking wire along garter (top) edge. Pin shawl out to schematic measurements with one pin in each crochet chain loop. Shawl will relax to finished measurements after removing pins. Allow to dry completely. Trim ends.

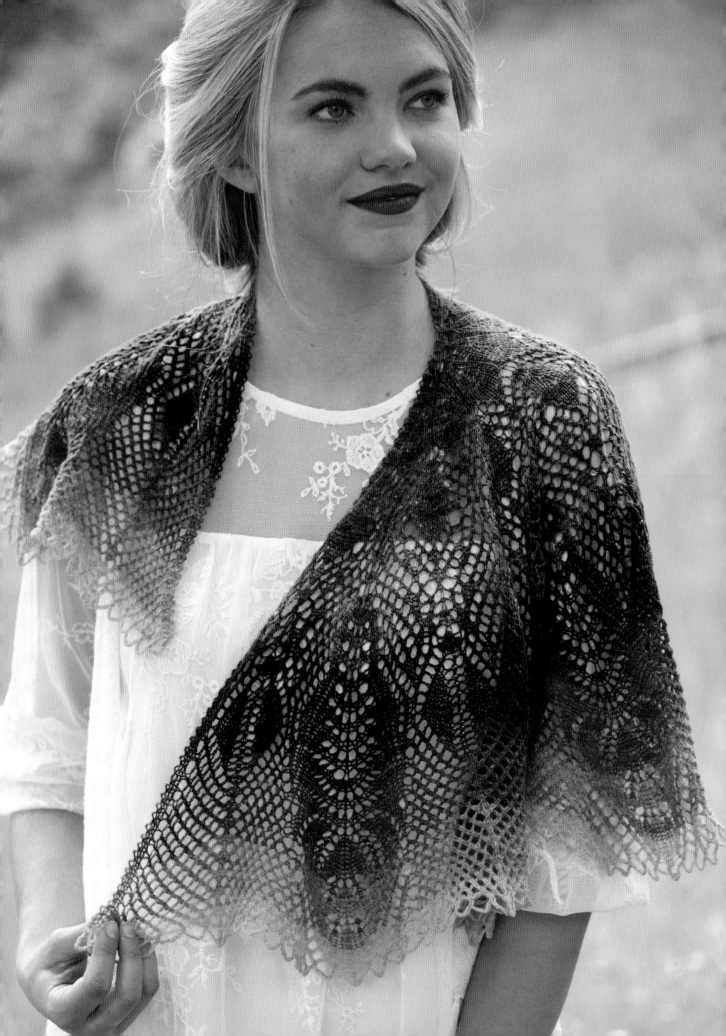

Chart A

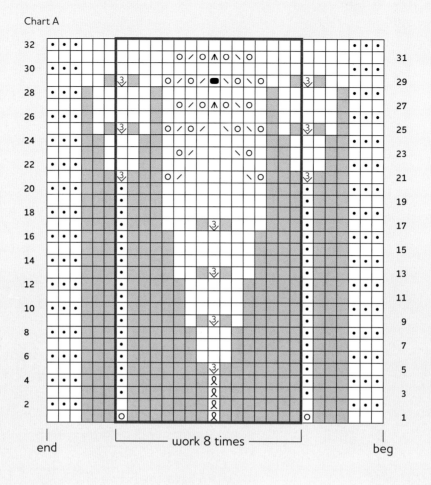

work 8 times

end

beg

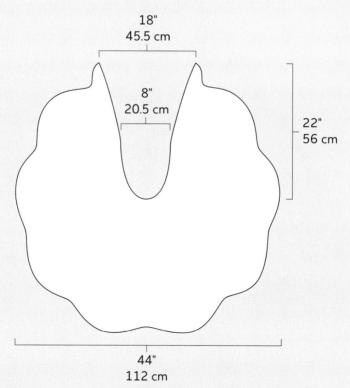

18"
45.5 cm

8"
20.5 cm

22"
56 cm

44"
112 cm

	k on RS, p on WS
•	p on RS, k on WS
ℒ	k1tbl o RS, p1tbl on WS
o	yo
╱	k2tog
╲	ssk
⋀	s2kp (see Techniques)
⋏	k3tog (see Techniques)
⋌	sssk (see Techniques)
③	knit into front, back, then front of same st
⑤	[(k1, p1) 2 times, k1] in same st
⑦	[(k1, p1) 3 times, k1] in same st
⋔	sssk, k4tog, psso
●	place bead (see Techniques)
M	make 1 by lifting horizontal bar from row below and knit without twisting
⌐X¬	crochet BO: gather sts indicated by bracket (see Stitch Guide), then chain the given number of sts
▨	no stitch
☐	pattern repeat

Chart B

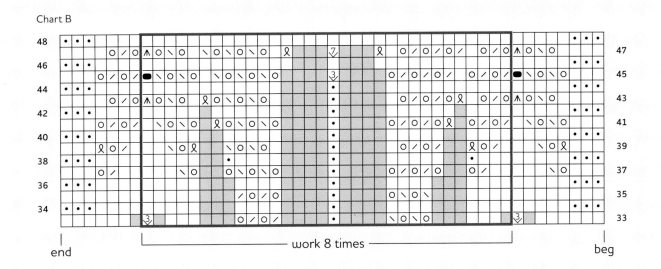

work 8 times

end

beg

Chart C

end

work 8 times

Chart D

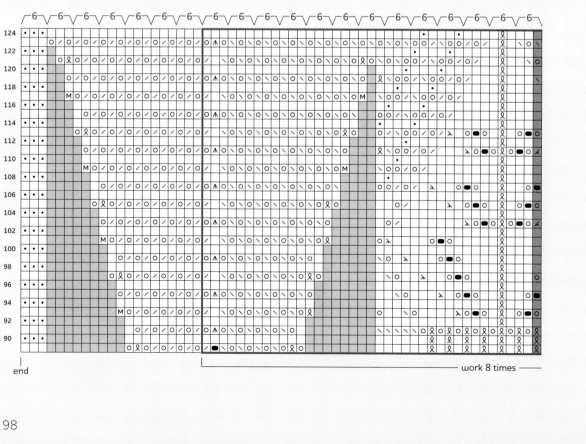

end

work 8 times

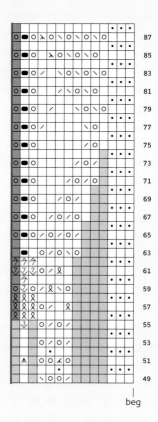

87
85
83
81
79
77
75
73
71
69
67
65
63
61
59
57
55
53
51
49

beg

Note: Stitches shaded purple are duplicated for ease of following the two halves of the chart; work the shaded stitches only once.

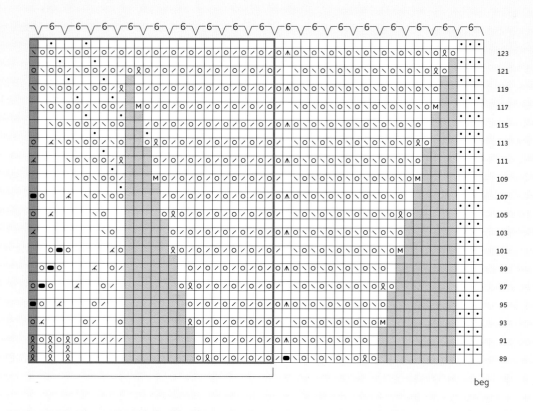

123
121
119
117
115
113
111
109
107
105
103
101
99
97
95
93
91
89

beg

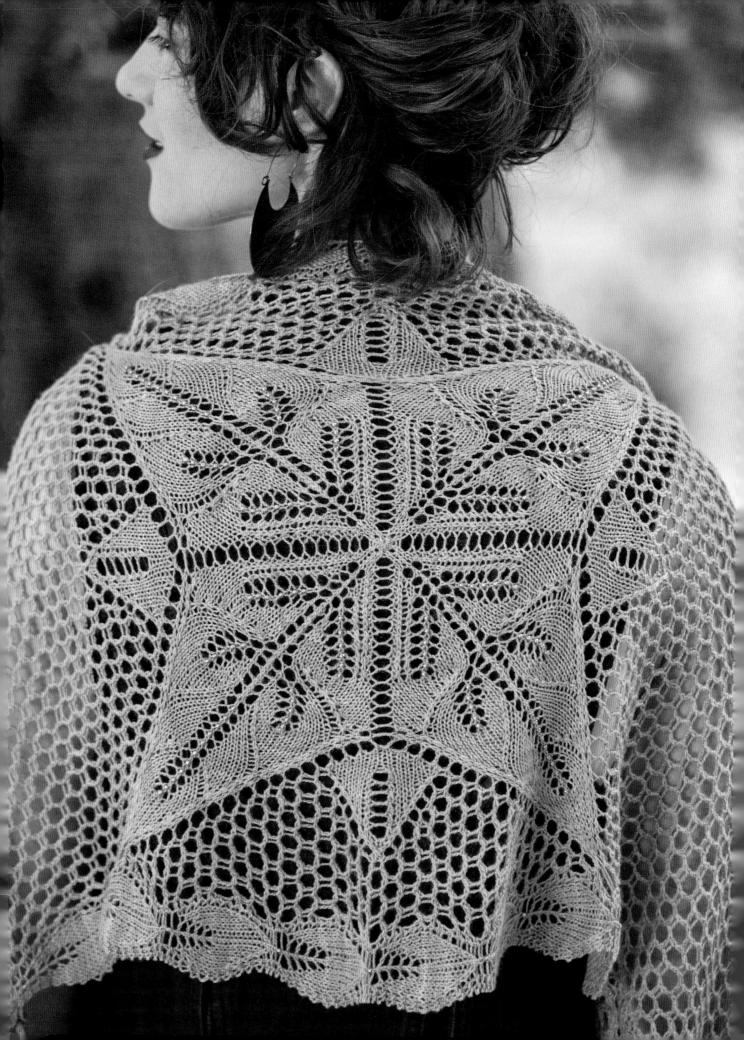

North America: Mount McKinley

Denali Stole

Denali means "the high one" in Athabaskan. Previously called Mount McKinley, the name was officially changed to Denali in 2015. The highest peak in North America, the summit is 20,237 feet (6,168 m) above sea level. The first well-documented ascent was in 1913, but the West Buttress route, which is the most popular one, was first documented in 1951. It can get extremely cold on top, with temperatures as low as -75°F (-59°C). Add windchill and it can get as cold as -118°F (-83°C). Bring good winter gear!

This project starts from the center, with large beaded leaf motifs. The hex-mesh "wings" are then worked out from opposite sides. Finally, a leaf border is worked along each long edge and finished at the points.

FINISHED SIZE

18" (45.5 cm) wide and 66" (167.5 cm) long.

YARN

Laceweight (#0 Lace).

Shown here: A Verb for Keeping Warm Reliquary II (80% superfine merino, 20% silk; 875 yd [800 m]/ 100 g): Succulent, 1 skein.

NEEDLES

Size U.S. 1.5 (2.5 mm): set of 5 double-pointed (dpn), 16" (40 cm), 24" (60 cm), 32" (80 cm), and 40" (100 cm) circular (cir). *Adjust needle size if necessary to obtain the correct gauge.*

NOTIONS

Smooth waste yarn; 20 g Toho 8/0 Japanese seed beads in olivine/color-lined metallic antique gold #378b; size U.S. 14 (0.6 mm) steel crochet hook, or size to fit beads; marker (m); locking markers (m) (optional); point protectors; cable needle (cn) (optional); small stitch holder; tapestry needle; stainless T-pins; blocking mats; 4 long very flexible blocking wires.

GAUGE

20 sts = 4" (10 cm) over St st, blocked and relaxed.

NOTES

Beads: See Techniques.

Managing double yarnovers at the start of the round: (on odd-numbered Rounds 3–35, 45–55, 63, 67, and 71). See Techniques.

Dealing with stitch markers when the beginning of the round shifts: I find it easier to use only one marker for the beginning of round. If you want to use a marker between every chart repeat, I have two suggestions. First, use a unique marker for your beginning of round because that one is critical. Second, treat each marker the same way you treat the beginning-of-round marker (see note above). When a double yarnover or a double decrease is worked over the marker, you will have to "borrow" a stitch from the next repeat and therefore will have to move the marker one stitch over and return it to the original spot once you are done.

All pattern rows are charted. Some portions of the shawl are worked in the round and others are worked back and forth. When working in the round, read all chart rows from right to left, and there are no wrong-side rows. When working back and forth, read right-side chart rows from right to left and wrong-side chart rows from left to right.

A word about slipping selvedge stitches. Don't! This piece was designed to block freely and slipped selvedge stitches will create a less flexible edge.

When you work on the double-pointed needles, use the yarn end from your cast-on to mark the beginning of the round. A locking marker can also be used if desired.

Two-Stitch Twist (Cable): See Techniques

There is a Two-Stitch Twist (Cable) straddling the beginning and end, and between each chart row repeat of Row 60 as follows: Slip marker at beginning of round. Knit 1. *Work to 1 stitch before end of chart row repeat, knit second stitch on left needle tip as shown in Techniques but do not remove from needle, knit first stitch through front loop, then slip both stitches from left needle. Repeat from * twice more. Work to just before last stitch of round. Slip that stitch onto right needle tip, remove marker, return stitch to left needle tip. Work final Two-Stitch Twist. Slip 1 stitch to left needle tip. Replace beginning-of-round marker to right needle tip. Begin Row 61.

DIRECTIONS

Center Square

With dpn, CO 8 sts using the long-tail method (see Techniques). Distribute sts evenly over 4 dpn, with 2 sts on each needle. Place marker (pm) for beg of rnd and join for working in rnds, being careful not to twist sts.

Next rnd: [K1tbl] around.

Next rnd: Working Row 1 of chart A, [k1tbl, yo, k1tbl] 4 times—4 sts inc'd.

Work Rows 2–72 of chart—304 sts. Change to shortest cir needle when there are too many sts to work comfortably on dpn, then to progressively longer cir needle as the number of sts increases. (See Notes about working double yarnovers at beginning/end of rnd and rep).

Cut yarn leaving a 9" (23 cm) tail. Sl 38 sts to RH needle. Place point protector onto right needle tip.

First Long End
With RS facing, rejoin yarn to left needle tip.

Next row: (RS) With 24" (60 cm) cir needle, work Row 1 of chart B over next 76 sts. Place second point protector on left needle tip of longer cir needle and leave these rem 228 sts hold.

***Next row:** (WS) Work over 76 sts on 24" (60 cm) cir needle only, work Row 2 of chart B as foll: beg at left edge of chart, work 2 sts before rep, work 4-st rep to last 2 sts, work 2 sts at right edge of chart after rep.

Work Rows 3 and 4, then rep Rows 1–4 thirty-three more times.

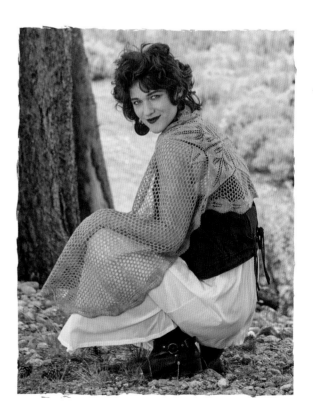

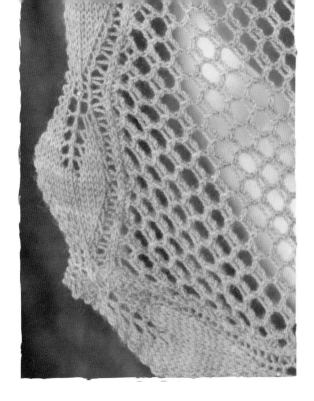

Next (dec) row: (RS) Work Row 1 of chart C as foll: beg at right edge of chart and work first 7 sts before rep, work 4-st rep to last 8 sts, then work 7 sts at left edge of chart after rep—2 sts dec'd.

Work Rows 2–8, then rep Rows 1–8 seven more times—12 sts rem.

Work Rows 9–16 once—4 sts rem.

Next (dec) row: (RS) Ssk, k2tog—2 sts rem.

Next row: Knit.

Next (dec) row: K2togtbl. Cut yarn leaving a 9" (23 cm) tail, pull tail through rem st.*

With RS facing, sl 76 sts to waste yarn, next 76 sts to 24" (60 cm) cir needle, then rem 76 sts to waste yarn.

Rejoin yarn to beg with a RS row, and work Row 1 over 76 sts. Rep from * to * for second long end.

Edging
Note: When picking up stitches along the point edges of the stole, lift the vertical strand of the garter stitch from the edge with the right needle tip. Make sure 212 rows have been worked along each long end, and pick up 1 loop for every 2 rows.

*With 40" (100 cm) cir needle and RS facing, beg at right point and pick up 106 sts by lifting along first long edge to held sts, sl 76 held sts from waste yarn along one side of center square to right needle tip, then pick up 105 sts along second long edge—287 sts.

Turn piece with WS facing. CO 4 sts using provisional method (see Techniques).

Next row: (RS) K3 sts just cast on, k2togtbl (last st cast on and 1 st from shawl), turn.

Next row: (WS) K1, p1, k2, turn.

Next row: Work Row 1 of Edging chart as foll: k2, yo, k1tbl, yo, k2tog (last edging st and next st from shawl), turn.

Next row: Work Row 2 of Edging chart.

Work Rows 3–26, then rep Rows 1–26 twenty-one more times, omitting bead on Row 25 of last rep—4 sts rem.*

Cut yarn leaving 18" (45.5 cm) tail. Place rem 4 sts onto holder.

Rep from * to * along second long edge but do not cut yarn.

Point
With RS facing, remove provisional CO from sts at beg of edging along first side and place 4 sts onto right needle tip—8 sts.

Next (dec) row: (RS) K2, ssk, k2tog, k2—6 sts rem.

Next row: K2, p2, k2.

Next (dec) row: K1, ssk, k2tog, k1—4 sts rem.

Next row: Knit.

Next (dec) row: Ssk, k2tog—2 sts rem.

Next (dec) row: K2tog—1 st rem. Cut yarn leaving 9" (23 cm) tail, pull tail through rem st.*

Return 4 held sts at rem end to dpn, remove provisional CO from beg of edging along second side and place 4 sts onto same dpn.

With RS facing, use long tail and work second tip same as first.

FINISHING
Weave in ends but do not trim. Soak in cool water until fully saturated (about 30 minutes). Press to remove water, roll in a towel, and blot to remove extra water.

Weave 2 blocking wires through garter bars along each long edge of piece. Pin out to schematic measurements, pinning each leaf to form scallops and the point at each end where wires cross. Allow to dry completely. Stole will relax to finished measurements after removing pins. Trim ends.

Chart A

work 4 times

* See Note on page 102 for
beginning round and each repeat with LT.

Chart B

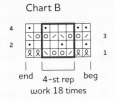

4
2
3
1

| end | 4-st rep | beg |

work 18 times

Chart C

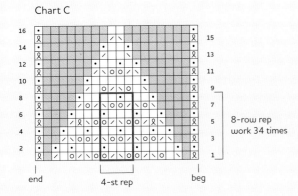

16
14
12
10
8
6
4
2

15
13
11
9
7
5
3
1

8-row rep
work 34 times

| end | 4-st rep | beg |

Edging chart

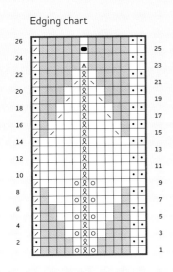

26
24
22
20
18
16
14
12
10
8
6
4
2

25
23
21
19
17
15
13
11
9
7
5
3
1

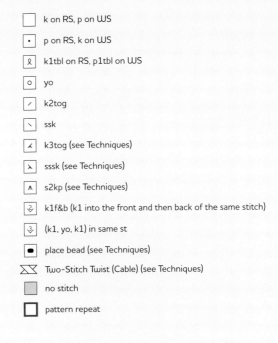

- ☐ k on RS, p on WS
- • p on RS, k on WS
- ℔ k1tbl on RS, p1tbl on WS
- o yo
- ╱ k2tog
- ╲ ssk
- �X k3tog (see Techniques)
- ⋏ sssk (see Techniques)
- ⋀ s2kp (see Techniques)
- ⥡ k1f&b (k1 into the front and then back of the same stitch)
- ⥥ (k1, yo, k1) in same st
- ⬛ place bead (see Techniques)
- ⋈ Two-Stitch Twist (Cable) (see Techniques)
- ▨ no stitch
- ☐ pattern repeat

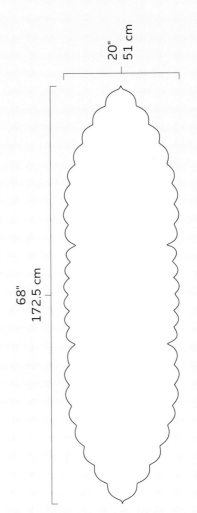

20"
51 cm

68"
172.5 cm

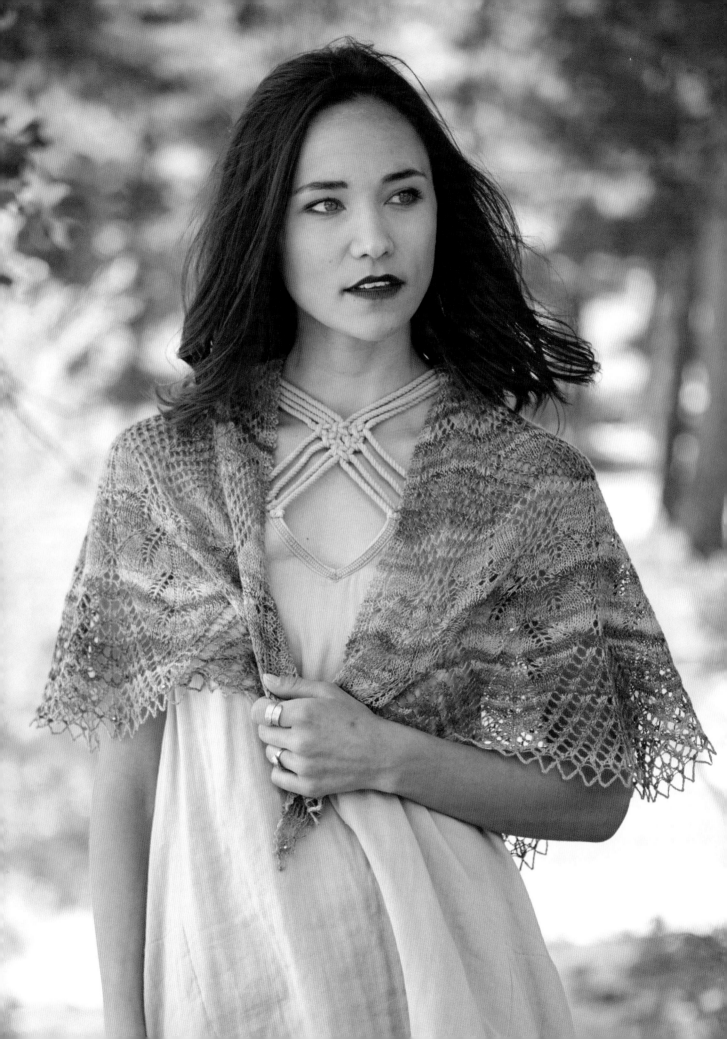

South America: Aconcagua

Indiecita Shawl

Aconcagua, in the Andes mountains of Argentina, is the highest mountain on the South American continent, at 22,837 feet (6,961 m). The first recorded ascent was in 1897 by a British expedition. It continues to be a popular climbing destination, and the youngest person documented to have reached the summit of Aconcagua was a nine-year-old, in 2013. The oldest documented climber was an eighty-seven-year-old, in 2007.

This project gives directions for a handspun version and one knit with a commercially available yarn in the identical fiber. The handspun version omits the beads, which are used liberally in the commercially available yarn version! There are two different bind-off options. The "EyeBrow" bind-off takes longer and uses more yarn, but it is well worth the effort. The handspun version shows the Gathered Crochet bind-off and the other shows the "EyeBrow."

FINISHED SIZE

Handspun version: 40½" (103 cm) wide and 19½" (49.5 cm) deep at center back. Malabrigo Lace version: 36" (91.5 cm) wide and 17½" (44.5 cm) deep at center back.

SPINNING MATERIALS

Malabrigo Nube (100% merino spinning fiber; 4 oz [113 g]): #NUB416 Indiecita.

0.9 to 1 oz drop spindle; small (sample size) niddy-noddy to skein spindle-spun yarn.

OR

YARN

Laceweight (#0 Lace).

Shown here: Malabrigo Lace (100% baby merino; 470 yd [430 m]/50 g): #LMBB039 Molly, 2 skeins.

NEEDLES

Size U.S. 2 (2.75 mm): 40" (100 cm) circular (cir). *Adjust needle size if necessary to obtain the correct gauge.*

NOTIONS

Smooth waste yarn for provisional cast-on; 8/0 Japanese seed beads: 21 beads for handspun version in Miyuki galvanized silver; 20 g for Malabrigo Lace version in Matsumo 823 gold-luster transparent pink/cinnamon; size U.S. 14 (0.6 mm) steel crochet hook, or size to fit beads; size U.S. 0 (1.75 mm) steel crochet hook for crochet bind-off; markers (optional); tapestry needle; stainless T-pins; blocking mats; three 60" (152.5 cm) lengths of flexible blocking wire.

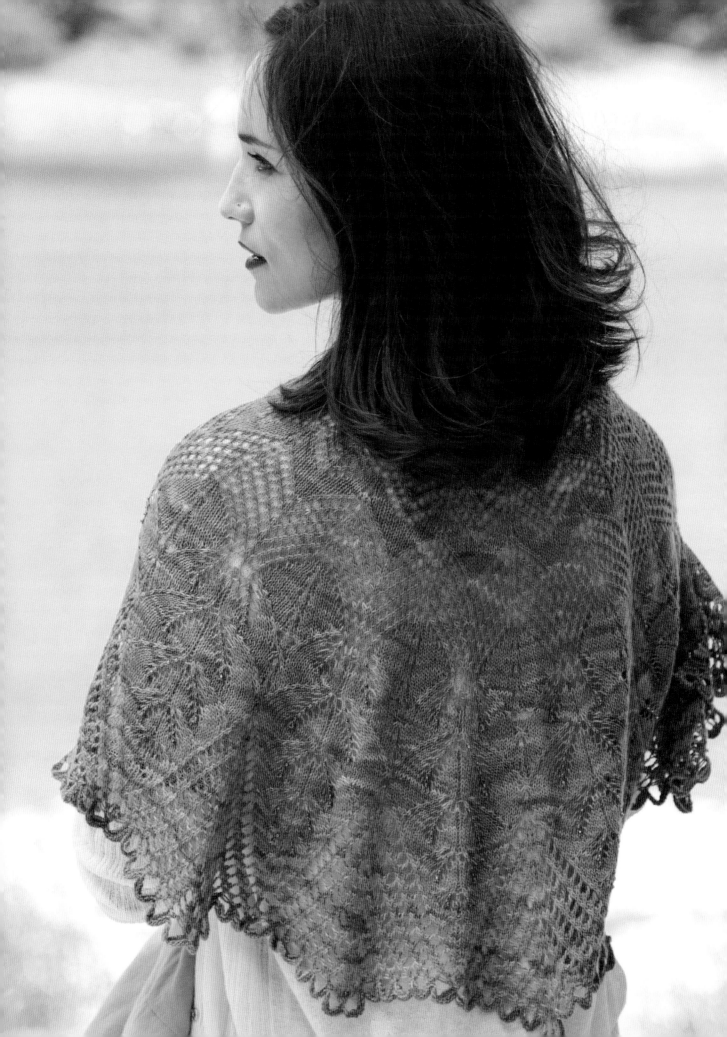

GAUGE

20 sts and 32 rows = 4" (10 cm) over St st, blocked and relaxed.

NOTES

Beads: See Techniques.

Gathered Crochet Bind-Off: See Techniques.

A word about slipping selvedge stitches: Don't! This piece was designed to block freely and slipped selvedge stitches will create a less flexible edge

DIRECTIONS FOR SPINNING

To prepare the fiber for spinning, unwind the hank of fiber and pull off a long, thin strip. Attenuate the fiber by gently grabbing sections and pulling it lengthwise, to loosen the fiber and make your strip as light and thin as practical. Tip: For the first spindle full, pull off as thin a strip as is comfortable, then for each time after that make the strip just a little thicker, allowing the colors to form stripes as you knit. Because the rows get longer as you work, the lengths of colors get longer as you spin using this method. Spin one entire strip using a lightweight drop spindle.

Andean ply the spindle cop for a balanced laceweight 2-ply.

Wind off your yarn using a sample niddy-noddy, secure the ends, soak it in cool water, and then dry unweighted.

Repeat for each strip.

Begin knitting using the skeins in the order that you spun them, joining each new skein as you come to the end of the previous skein. You can spit-splice or just overlap the two ends for three stitches and then weave them in at the end.

DIRECTIONS FOR KNITTING

CO 3 sts using provisional method (see Techniques).

Knit 11 rows.

Next row: K3, do not turn work, but rotate piece 90 degrees right, then pick up and purl 5 sts along the left side edge (1 st in each garter ridge), turn the work another 90 degrees right and pick up and knit 3 sts in provisional CO, removing waste yarn—11 sts.

Turn work.

Next (inc) row: K3, [k1f/b] 5 times, k3—16 sts.

Next row: K3, p10, k3.

Next row: (RS) Work Row 1 of chart A as foll: beg at right edge of chart and work 4 sts before rep, work 2-st rep 10 times, then work 3 sts at left edge of chart after rep—27 sts.

Next row: Work Row 2 of chart, beg at left edge of chart and work 3 sts before rep, work 2-st rep 10 times, then work 4 sts at right edge of chart after rep.

Work Rows 3–50 of chart A as established—186 sts.

Work Rows 51–82 of chart B—307 sts.

Work Rows 83–110 of chart C—387 sts.

Work Rows 111–140 of chart D—507 sts.

BO using one of the foll options:

Gathered Crochet BO: [Gather 3 sts, ch 6] 2 times, *[gather 4, ch 8] 5 times, gather 5, ch 8, [gather 4, ch 8] 5 times, gather 5, ch 8; rep from * 8 more times, [gather 4, ch 8] 5 times, gather 5, ch 8, [gather 4, ch 8] 4 times, gather 4, ch 6, gather 3, ch 6, gather 3. Cut yarn leaving a 9" (23 cm) tail, pull tail through rem st.

EyeBrow BO: [K3togtbl, cable CO 6 sts (see Techniques)] 2 times, *[k4togtbl, cable CO 8] 5 times, k5togtbl, cable CO 8, [k4togtbl, cable CO 8] 5 times, K5togtbl, cable CO 8; rep from * 8 more times, k4togtbl, cable CO 8] 5 times, k5togtbl, cable CO 8, [k4togtbl, cable CO 8] 4 times, k4togtbl, cable CO 6, k3togtbl, cable CO 6, k3togtbl—1,091 sts.

Next row: (WS) Knit.

BO row: (RS) [K2togtbl, return st to left needle tip] to last 2 sts, k2togtbl. Cut yarn leaving a 9" (23 cm) tail, pull tail through rem st.

FINISHING

Weave in ends but do not trim. Soak in cool water until fully saturated (about 30 minutes). Press to remove water, roll in a towel and blot to remove extra water.

Weave one long blocking wire along top edge, and two rem wires through crochet or "eyebrow" loops along bottom edge. Pin out schematic measures, creating gentle scallops along bottom edge. Allow to dry completely. Shawl will relax to finished measurements after removing pins. Trim ends.

Legend:

□ k on RS, p on WS

· p on RS, k on WS

⋉ k1tbl on RS, p1tbl on WS

○ yo

╲ k2tog

╱ ssk

▲ s2kp (see Techniques)

◄ k3tog (see Techniques)

► sssk (see Techniques)

Z [k3tog, yo, k3tog] in same 3 sts

● place bead (see Techniques)
 Note: For handspun version, place beads on row 139 only;
 all other rows, k1

⌐X⌐ crochet BO or Eyebrow BO (see Stitch Guide),
 then chain the given number of sts

▨ no stitch

□ pattern repeat

Chart A

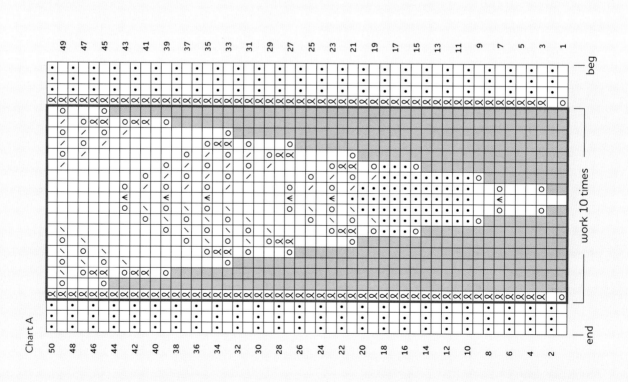

beg

49
47
45
43
41
39
37
35
33
31
29
27
25
23
21
19
17
15
13
11
9
7
5
3
1

work 10 times

end

50
48
46
44
42
40
38
36
34
32
30
28
26
24
22
20
18
16
14
12
10
8
6
4
2

110

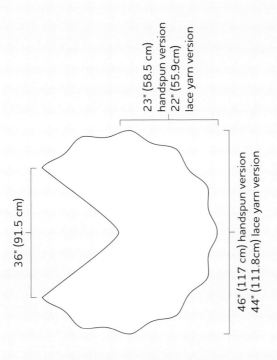

36" (91.5 cm)

23" (58.5 cm) handspun version
22" (55.9cm) lace yarn version

46" (117 cm) handspun version
44" (111.8cm) lace yarn version

Chart B

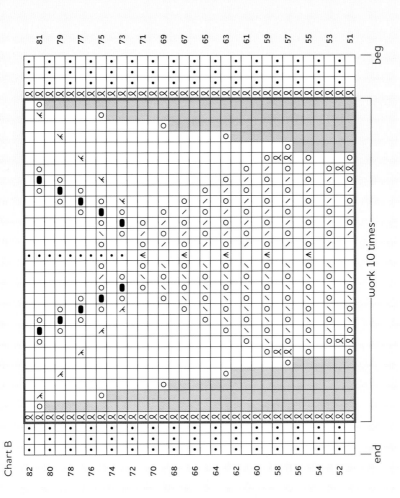

Chart C

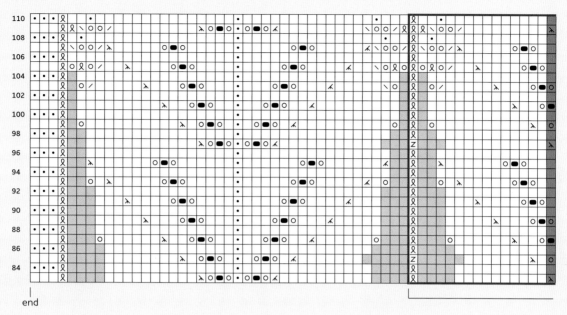

|
end

Chart D

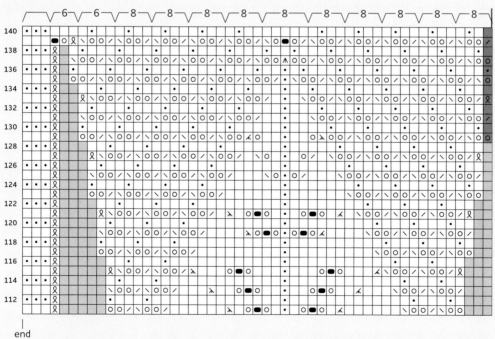

|
end

*Note: Stitches shaded purple are duplicated for ease of following
the two halves of the chart; work the shaded stitches only once.*

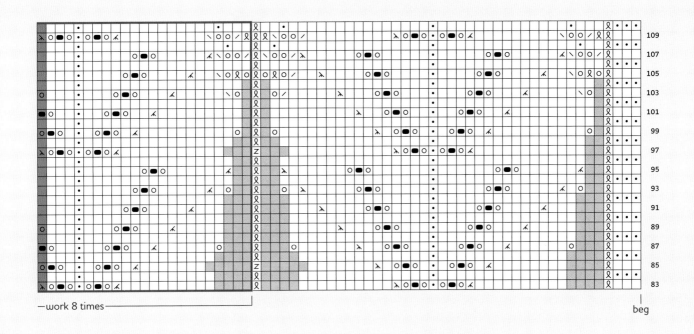

—work 8 times—

beg

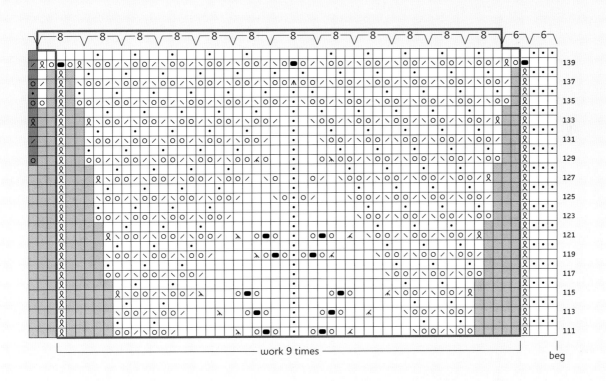

— work 9 times —

beg

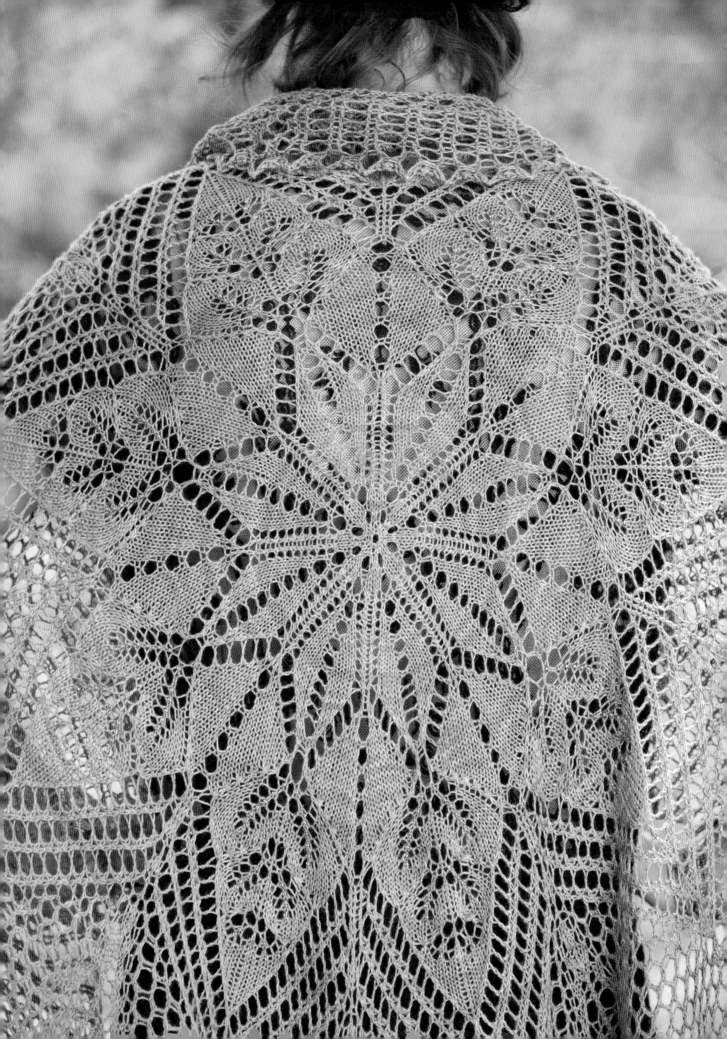

Asia: Mount Everest (Qomolangma)

Goddess of Infinite Giving

Mount Everest (known as Qomolangma to Tibetans), at 29,029 feet (8,848 m) above sea level, is the highest mountain on the earth. Its massif includes several peaks above 24,000 feet (7,500 m). Sir Edmund Hillary and Tenzing Norgay made the first official ascent of Mount Everest in 1953. It has been climbed many times since then.

Miyolangsangma, the Tibetan Buddhist goddess, lives at the top of Qomolangma. Known as the goddess of infinite giving, she rides a golden tiger and hands out jewels (wishes) to those who deserve them. Many climbers ask for her gifts before beginning their ascent. This piece is a full circle, a mandala if you will, which represents wholeness.

FINISHED SIZE

56" (142 cm) diameter, relaxed after blocking.

YARN

Laceweight (#0 Lace).

Shown here: Jade Sapphire Khata (50% yak, 50% silk; 700 yd [640 m]/100 g): #K6 Celestial Orchid, 2 skeins.

NEEDLES

Size U.S. 3 (3.25 mm): set of 5 double-pointed (dpn), 16" (40 cm), 24" (60 cm), 32" (80 cm), and 40" (100 cm) circular (cir). *Adjust needle size if necessary to obtain the correct gauge.*

NOTIONS

Smooth waste yarn; 20 g Miyuki 8/0 Japanese seed beads in color #319 tran light sapphire/violet luster; size U.S. 14 (0.6 mm) steel crochet hook, or size to fit beads; marker (m); locking marker (m) (optional);tapestry needle; stainless T-pins; blocking mats.

GAUGE

24 sts = 4" (10 cm) over St st, blocked and relaxed.

NOTES

Beads: See Techniques.

Nupps: See Techniques.

Rounds 35, 39, 43, 47, 51, 56, 99, 107, 111, 115, 119, 123, 127, 131, 135, 139, 143, 147, and 188 begin each round/repeat with a double yarnover. See Techniques.

When you work on the double-pointed needles, use the yarn end from your cast-on to mark the beginning of the round. A locking marker can also be used if desired.

Two-Stitch Twist (Cable): See Techniques

STITCH GUIDE

BO nupp: Insert left needle tip, from front to back under horizontal bar between last st worked and next st, [(k1, yo) 2 times, k1], return 5 sts just made to left needle tip, k5tog.

DIRECTIONS

With dpn, CO 8 sts using long-tail method (see Techniques). Use yarn end or place marker (pm) for beg of rnd and join for working in rnds, being careful not to twist sts.

Next rnd: K1tbl around.

Change to cir needle when there are too many sts to work comfortably on dpn, then to progressively longer cir needle as number of sts increases.

Work Rows 1–56 of chart A—248 sts.

Work Rows 57–74 of chart B—320 sts.

Work Rows 75–102 of chart C—448 sts.

Work Rows 103–122 of chart D—536 sts.

Work Rows 123–150 of chart E—648 sts.

Work Rows 151–158 of chart F—680 sts.

Work Rows 159–166 of chart G—712 sts.

Work Rows 167–174 of chart H—744 sts.

Work Rows 175–186 of chart I—792 sts.

Work Rows 187–190 of chart J—808 sts.

BO rnd: K2, return 2 sts just worked to LH needle, k2tog, *BO nupp (see Stitch Guide), return 2 sts to LH needle, k2tog, [k1, return 2 sts to LH needle, k2tog] 4 times; rep from * 18 more times,

BO nupp, return 2 sts to LH needle, k2tog, [k1, return 2 sts to LH needle, k2tog] 4 times,

**(BO nupp, return 2 sts to LH needle, k2tog, [k1, return 2 sts to LH needle, k2tog] 4 times) 24 times,

BO nupp, return 2 sts to LH needle, k2tog, [k1, return 2 sts to LH needle, k2tog] 4 times; rep from ** 6 more times,

***BO nupp, return 2 sts to LH needle, k2tog, [k1, return 2 sts to LH needle, k2tog] 4 times; rep from *** 3 more times,

BO nupp, return 2 sts to LH needle, k2tog, [k1, return 2 sts to LH needle, k2tog] 2 times. Cut yarn leaving a 9" (23 cm) tail, pull tail through rem st.

FINISHING

Weave in ends but do not trim. Soak in cool water until fully saturated (about 30 minutes). Press to remove water, roll in a towel, and blot to remove extra water.

Block to 60" (152.5 cm) diameter. Shawl will relax to finished measurements after removing pins. Note: Use a ruler to measure the radius of each section as you pin it out, first in quarters, then eighths. Pin each eyelet from the last eyelet round and so each nupp lies between each pinned eyelet, creating picots along the edge when pins are removed.

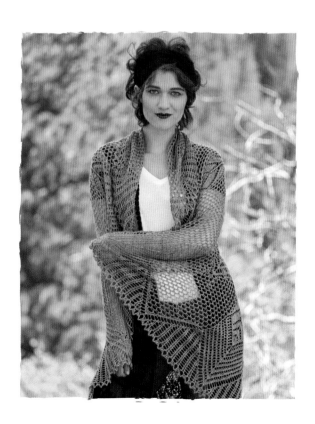

TIPS AND TRICKS

1. Use the tail from your cast-on as the beginning-of-round marker when you begin on the double-pointed needles. You can add a "real" marker when you switch to circular needles.

2. When I work a six- or twelve-segment piece I use a set of four double-pointed needles. I arrange the stitches on three needles and work with the fourth. When I work a four- or eight-segment piece I use a set of five double-pointed needles. I arrange the stitches on four and work with the fifth.

3. When I begin a four- or eight-segment piece in the round, I start with four needles (stitches on three, working with fourth) for the first few rounds. Once it is past the point it can twist I add the fifth needle.

4. How can you tell how many segments the piece is when you are working in the round? How many times are you repeating the chart? In this pattern we are repeating the chart eight times per round and there are eight segments. Puncák Jaya and Denali, also started in the round, repeat four times per round, and there are four segments.

Chart A

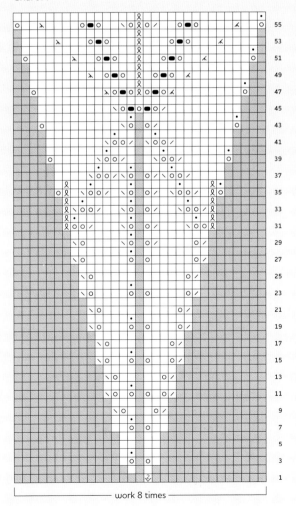

— work 8 times —

	knit
•	purl
ℛ	k1tbl
o	yo
⅋	k1f/b
∕	k2tog
＼	ssk
⅄	k3tog (see Techniques)
⅄	sssk (see Techniques)
⋏	s2kp (see Techniques)
⅄	ssssk (see Techniques)
4	k4tog (see Techniques)
⅃	([k1, yo] 3 times, k1) in same st
↑	k7tog
●	place bead (see Techniques)
⋈	Two-Stitch Twist (Cable) (see Techniques)
	no stitch
	pattern repeat

117

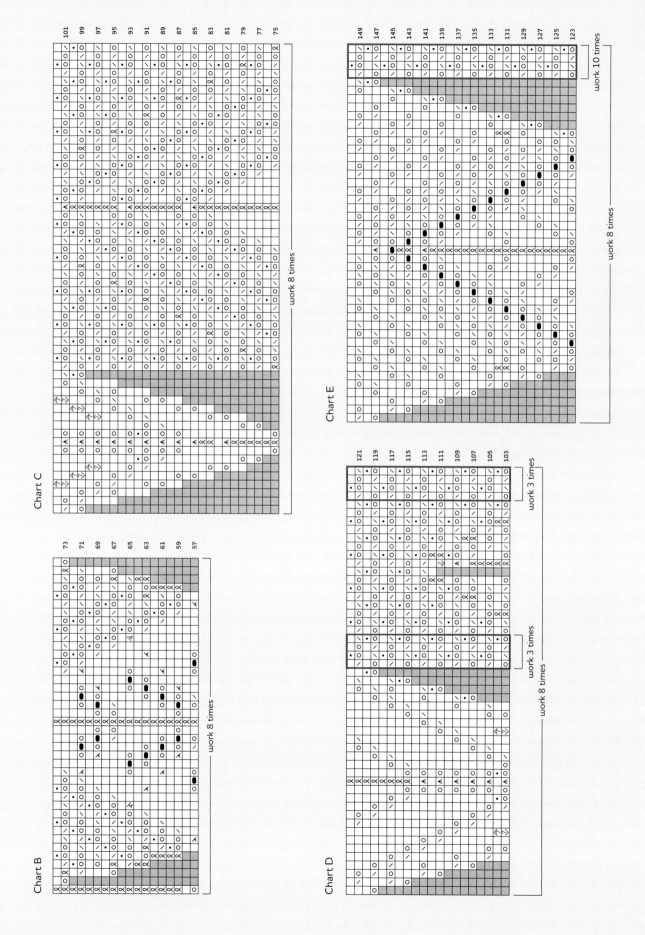

Chart B

Chart C

Chart D

Chart E

118

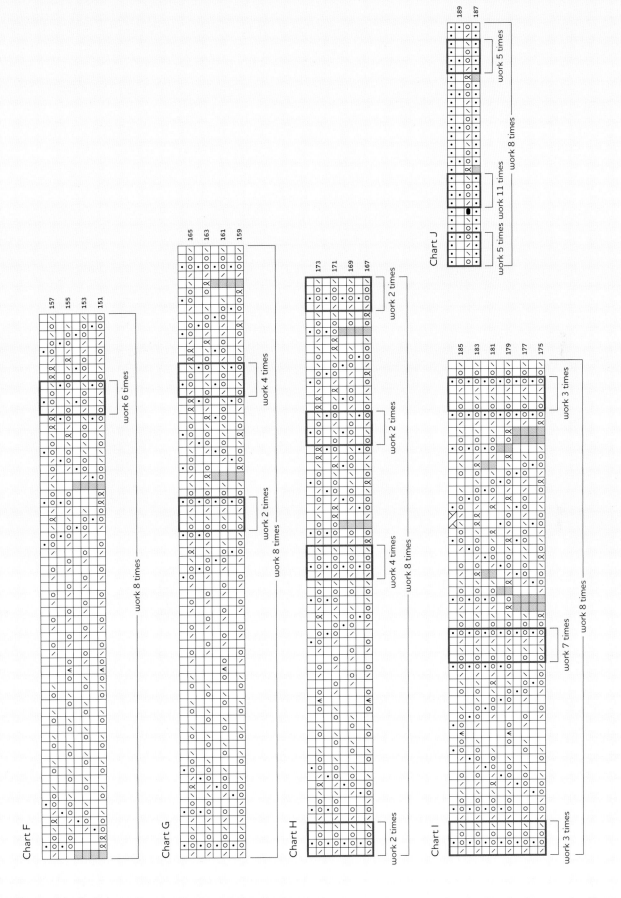

Chart F

Chart G

Chart H

Chart I

Chart J

Chapter 6

THE EIGHTH SUMMIT: GEOMETRY OF A TRIANGLE

Every mountain has more than one trail that will get you to the summit. Some paths might be longer, some easier, some very challenging. But almost every climb can be approached from several trailheads. With that in mind, I would like to consider the triangle as a shawl.

© iStockphoto.com/DOUGBERRY

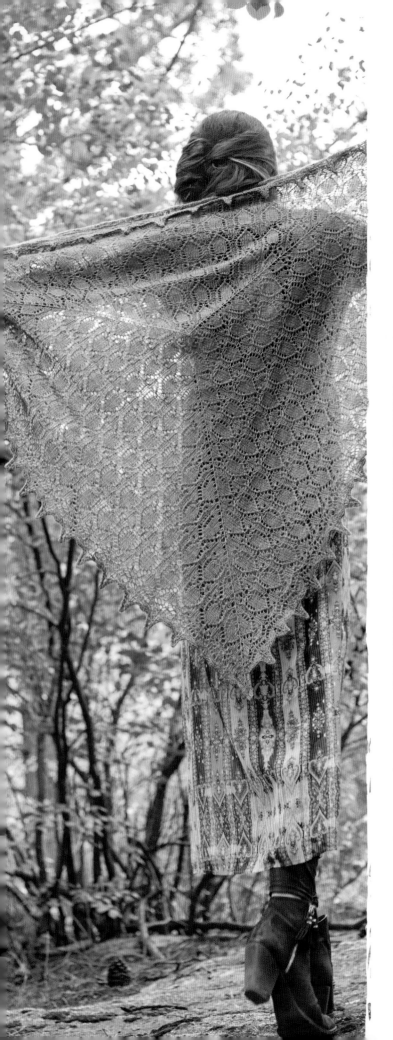

In my first book, *New Vintage Lace* (Interweave, 2014), I reviewed doily geometry in the final chapter. There, we considered various increase rates for circles broken into several different segments. Circles are all round and all have 360 degrees. Triangles, on the other hand, come in various configurations. First, let's consider the basics. A triangle always has three sides and three angles, and those three angles always add up to 180 degrees.

An equilateral triangle has three equal sides and three equal angles. When we divide 180 by 3 we get 60, so we know that all three angles will be 60 degrees. And by definition it will also be an acute triangle! So the types are not necessarily exclusive. You can review the table and see which of the projects here fall into which category.

Type of Triangle	Projects in the category
Equilateral (3 equal sides and 3 equal angles)	Pacific Crest
Right triangle (has one 90-degree angle)	Persian Sunrise, Franconia Traverse
Obtuse (has one angle more than 90 degrees)	Charlotte Pass
Isosceles (has 2 equal sides and 2 equal angles)	Persian Sunrise
Scalene (Has no equal sides or angles)	Franconia Traverse
Acute (all 3 angles are less than 90 degrees)	Pacific Crest

Just as there are quite a few different types of triangles, so are there quite a few ways to approach a triangular shawl. We can start at the bottom tip and work up and out equally, using either an isosceles right triangle or an obtuse triangle, based on the rate of increase we select. If you would like a right triangle, simply increase one stitch on each edge, every other row. If you would like an obtuse triangle, we can just increase one stitch on each edge, every row.

ISOSCELES RIGHT TRIANGLE WORKED FROM
THE TIP UP

OBTUSE TRIANGLE WORKED FROM THE TIP UP

We can start at the bottom tip and increase on one side only, working up and across from a right angle (Franconia Traverse).

SCALENE TRIANGLE

We can start at one side (angle), increasing on one edge only, until we reach the halfway point and then decrease along the same edge until we reach the far side angle.

OBTUSE TRIANGLE WORKED FROM ONE SIDE

We can begin with a provisional cast-on at the center back and work out and down, creating an isosceles right triangle (Persian Sunrise).

ISOSCELES RIGHT TRIANGLE WORKED FROM
THE NECK DOWN

We can start at the center on double-pointed needles and work out for an equilateral triangle (Pacific Crest).

EQUILATERAL TRIANGLE WORKED FROM
THE CENTER OUT

There are an unlimited number of possibilities, but two projects follow that I think will whet your appetite for experimenting.

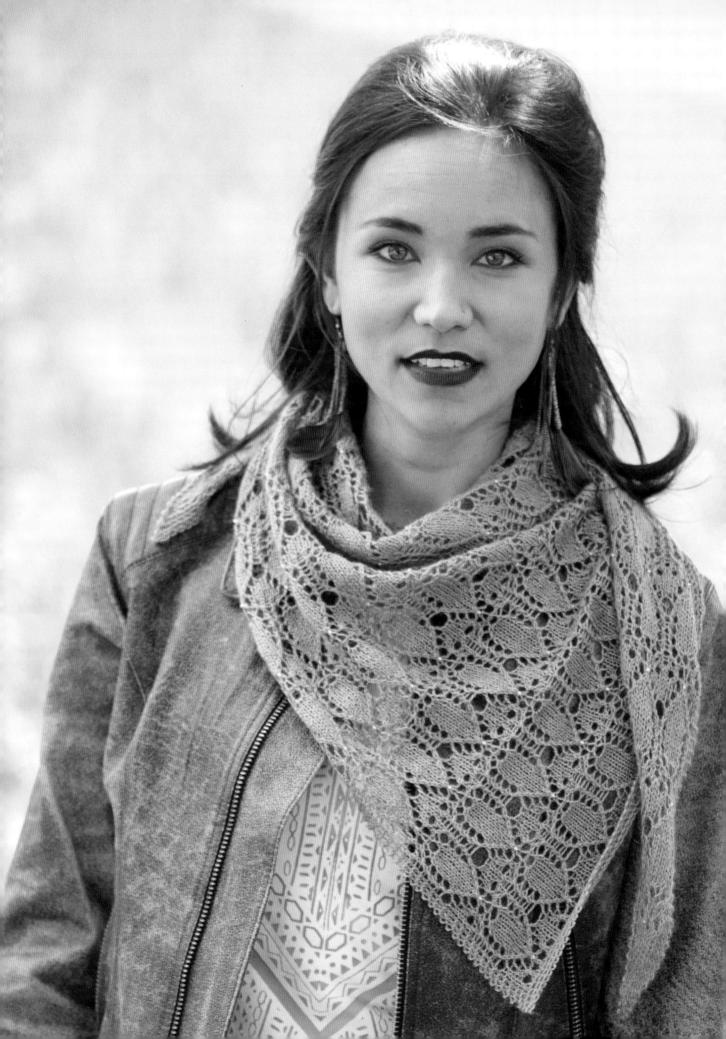

A Scalene Triangle

Franconia Traverse Wrap

Franconia Traverse is a nine-mile section of the Appalachian Trail that runs through the White Mountains, in New Hampshire. If you look carefully you can see alpine wildflowers along the way.

A scalene triangle is one in which all three sides and all three angles are different. A 30-60-90 triangle is a very special example. The longest side (the hypotenuse) is opposite the one 90-degree (right) angle and is twice the length of the shortest side. That shortest side is the one on our knitting needle as we work this piece from the first angle, increasing along only one edge, every other row as we knit. This piece is worn with the hypotenuse as the top edge and is asymmetrical. You can continue increasing, repeating the row repeat, for as long as you like, limited only by your yarn and bead supply.

FINISHED SIZE

52" (132 cm) wide along the hypotenuse and 21½" (54.5 cm) long at center back.

YARN

Laceweight (#0 Lace).

Shown here: The Fibre Company Road to China Lace (65% baby alpaca, 15% silk, 10% camel, 10% cashmere; 656 yd [600 m]/100 g): Blue Diamond, 1 skein.

NEEDLES

Size U.S. 2 (2.75 mm): 24" (60 cm) circular (cir). *Adjust needle size if necessary to obtain the correct gauge.*

NOTIONS

20 g Miyuki 8/0 Japanese seed beads in sparkling pewter-lined crystal; size U.S. 14 (0.6 mm) steel crochet hook, or size to fit beads; markers (optional); tapestry needle; stainless T-pins; blocking mats; three 60" (152.5 cm) lengths of flexible blocking wire.

GAUGE

24 sts = 4" (10 cm) over St st, blocked and relaxed.

NOTES

Beads: See Techniques.

A word about slipping selvedge stitches: Don't! This piece was designed to block freely, and slipped selvedge stitches will create a less flexible edge

There will be enough yarn to make the wrap larger if desired. Should you choose to make the wrap larger, be sure to get more beads.

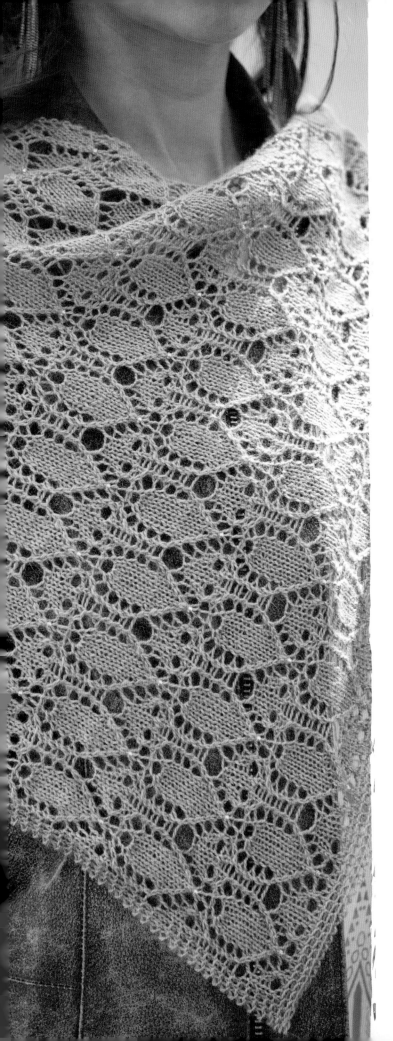

DIRECTIONS

CO 3 sts using long-tail method (see Techniques).

Row 1: (RS) Beg at right edge of chart, k3.

Row 2: (WS) Beg at left edge of chart, k3.

Work Rows 3–42 as established—22 sts.

Next row: (RS) Working Row 23 of chart, beg at right edge of chart, work 3 sts before rep, work 9-st rep to last st, work 2 sts at left edge of chart after rep—1 st inc'd.

Next row: Working Row 24 of chart, beg at left edge of chart, work 2 sts before rep, work 9-st rep to last 3 sts, work 3 sts at right edge of chart after rep.

Work chart Rows 25–42, then rep Rows 23–42 thirteen more times, working one additional rep each time—148 sts.

Work chart Rows 43–46.

BO as foll, making sure to work evenly but loosely: K2, return 2 sts just worked to left needle tip, k2togtbl, [k1, return 2 sts just worked to left needle tip, k2togtbl] to end. Cut yarn leaving a 9" (23 cm) tail, pull tail through rem st.

FINISHING

Weave in ends but do not trim. Soak in cool water until fully saturated (about 30 minutes). Press to remove water, roll in a towel, and blot to remove extra water.

Weave a blocking wire through the vertical strand of garter st along each edge. Pin out to schematic measurements, so longest edge (the hypotenuse) has a slight concave shape. Allow it to dry completely. Shawl will relax to finished measurements when pins are removed. Trim ends.

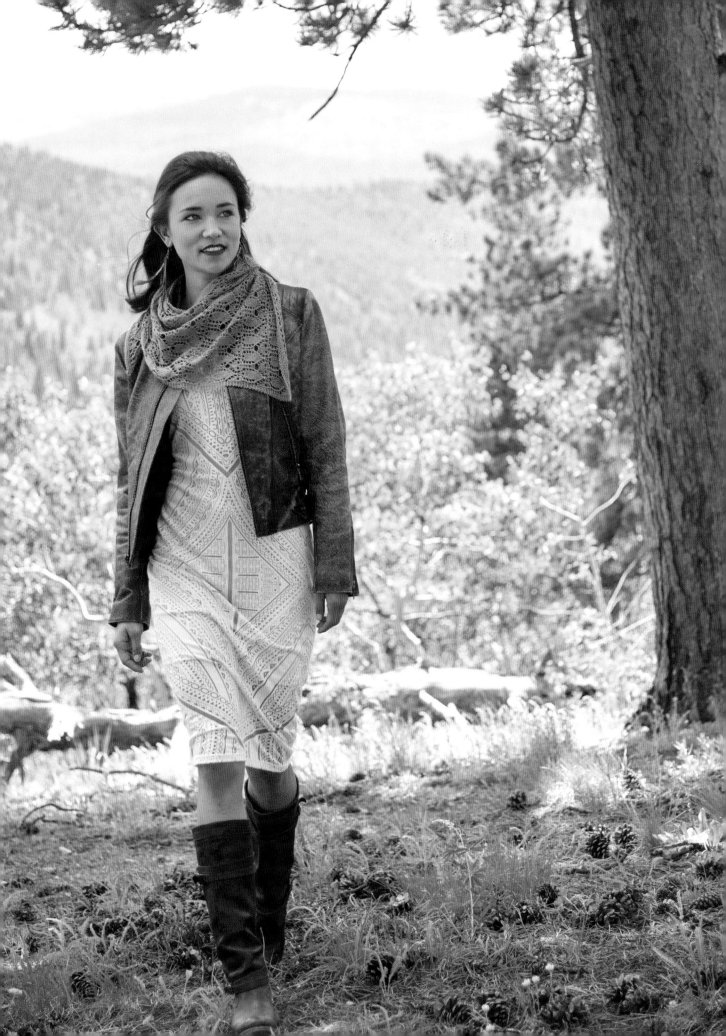

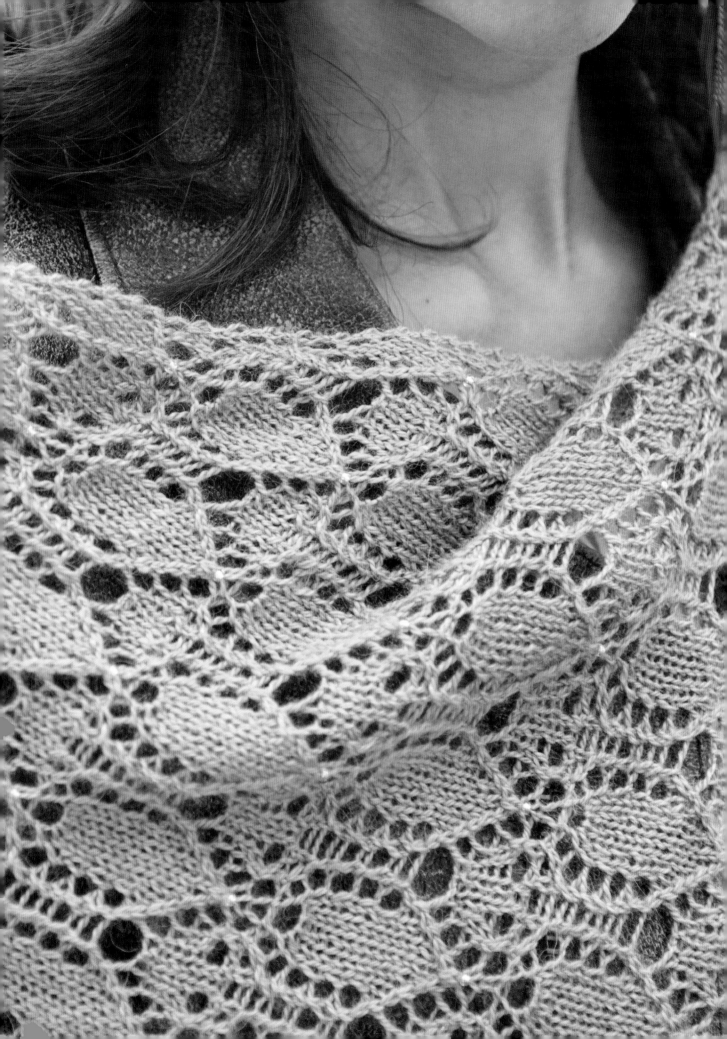

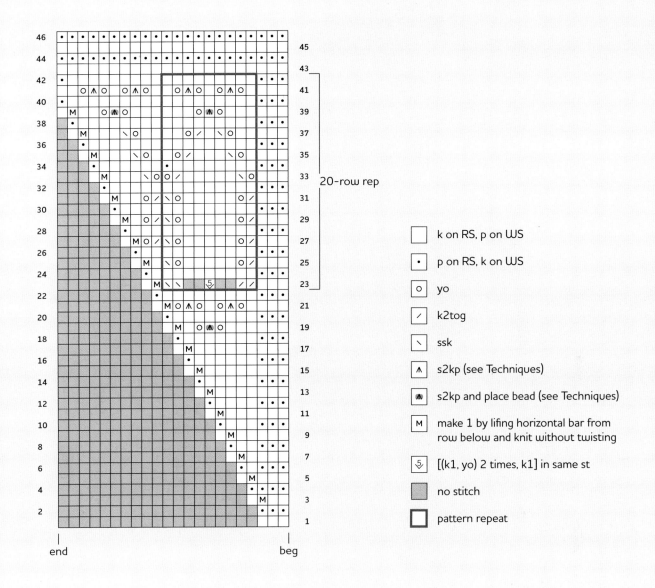

46
45
44
43
42
41
40
39
38
37
36
35
34
33
32
31
30
29
28
27
26
25
24
23
22
21
20
19
18
17
16
15
14
13
12
11
10
9
8
7
6
5
4
3
2
1

20-row rep

end

beg

k on RS, p on WS

· p on RS, k on WS

o yo

/ k2tog

\ ssk

⋀ s2kp (see Techniques)

⋀ s2kp and place bead (see Techniques)

M make 1 by lifing horizontal bar from row below and knit without twisting

⑤ [(k1, yo) 2 times, k1] in same st

no stitch

pattern repeat

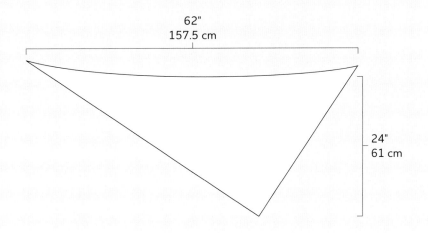

62"
157.5 cm

24"
61 cm

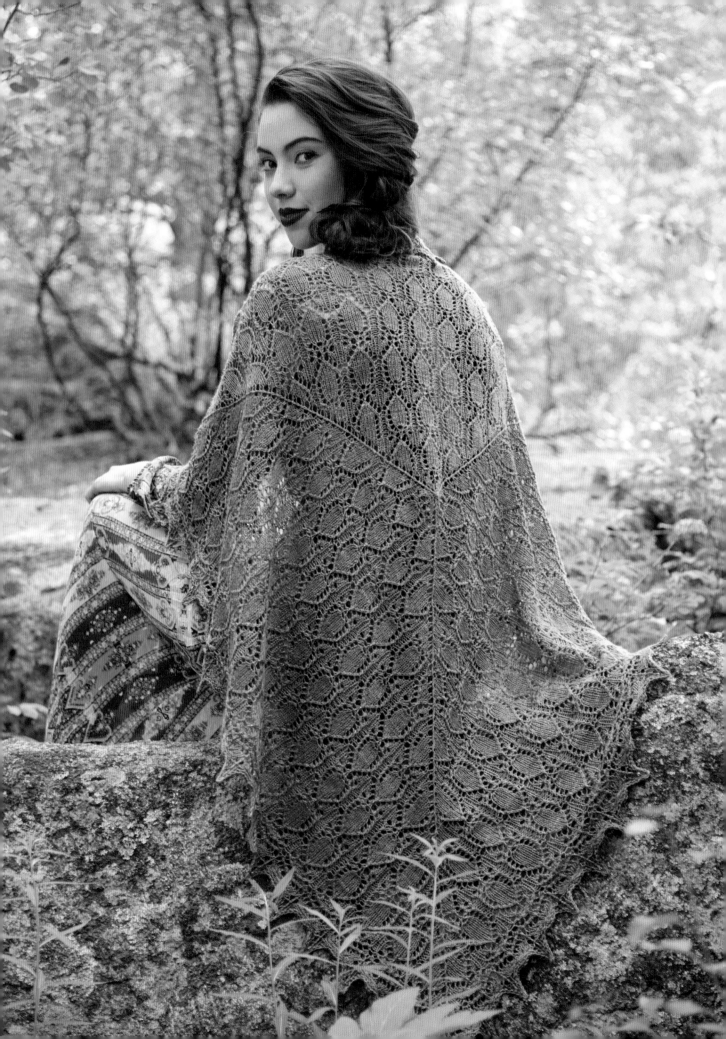

An Equilateral Triangle

Pacific Crest Shawl

The Pacific Crest Trail is 2,663 miles (4,285 km) long and runs from the Canadian border down through California along some of the highest peaks in the Cascade and Sierra Nevada mountain ranges. It is part of the Great Western Loop, which is 6,875 miles (11,062 km) long and is one of the classic long-distance hikes in the United States.

An equilateral triangle is a triangle with three equal sides and three equal angles. This triangle is one of the most fun and surprising to work, because the three increase lines are a little like playing with a kaleidoscope, and the leaves and vines that form are fun to watch as they develop.

This project begins on double-pointed needles and grows out from the center, worked in the round. As shown, the repeat charts (B–D) are worked a total of two times, but you can make the piece larger by working them a third time if you have enough yarn and beads! This is another riff on the stitch pattern I designed for the Mount Elbrus triangle. Have fun!

FINISHED SIZE

28" (71 cm) from center to point of triangle and 49½" (125.5 cm) across side.

YARN

Laceweight (#0 Lace).

Shown here: Miss Babs Yet (65% merino, 35% tussah silk; 400 yd [366 m]/ 65 g): Coos Bay, 3 skeins.

NEEDLES

Size U.S. 4 (3.5 mm): set of 4 double-pointed (dpn), 24" (60 cm), 32" (80 cm), and 40" (100 cm) circular (cir). *Adjust needle size if necessary to obtain the correct gauge.*

NOTIONS

20 g Miyuki 8/0 Japanese seed beads in silver-lined dark peacock AB #643B; 63 Czech 6/0 seed beads in metallic teal-lined crystal; size U.S. 14 (0.6 mm) steel crochet hook, or size to fit beads; markers (m); tapestry needle; stainless T-pins; blocking mats.

GAUGE

20 sts and 34 rnds = 4" (10 cm) over St st, blocked and relaxed.

NOTES

Beads: See Techniques.

When you work on the double-pointed needles, use the yarn end from your cast-on to mark the beginning of the round. A locking marker can also be used if desired.

STITCH GUIDE

Cluster: Slip 5 sts, one at a time, knitwise, return sts to left needle tip in their new orientation, insert right needle tip into back loops from right to left and ([k5tog tbl yo] 2 times, k5togtbl).

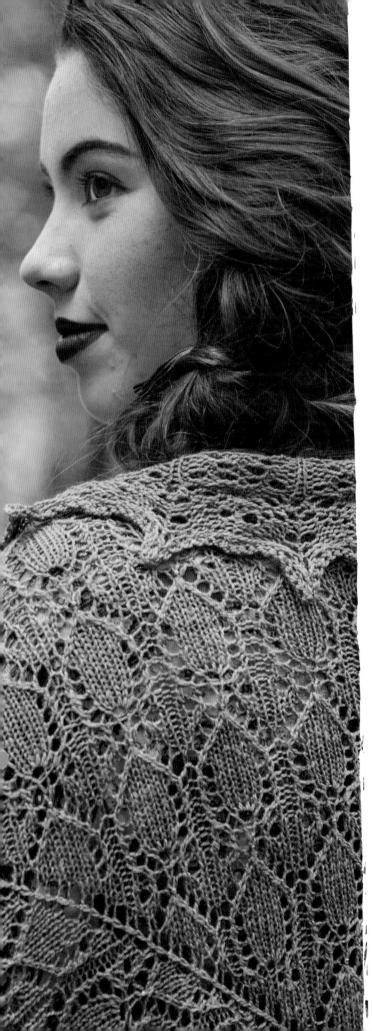

DIRECTIONS

With dpn, CO 6 sts using long-tail method (see Techniques). Distribute sts evenly over 3 dpn. Use yarn tail or place locking marker (pm) for beg of rnd, and join for working in rnds, being careful not to twist sts.

Next rnd: K1tbl around.

Next rnd: Work Rnd 1 of chart A around—9 sts.

Work Rows 2–31 in established patt—126 sts. Change to cir needle when there are too many sts to work comfortably on dpn, then change to longer cir needle as number of sts increases.

Work Rows 32–51 of chart B—84 sts inc'd.

Work Rows 52–71 of chart C—78 sts inc'd.

Work Rows 72–91 of chart D—78 sts inc'd.

Work charts B, C, and D once more—606 sts.

Work Rows 92–103 of chart E—900 sts.

Work Rows 104 and 105 of chart F—1,164 sts.

BO rnd: Working evenly but loosely, k2, return 2 sts just worked to LH needle tip, k2togtbl, [k1, return 2 sts just worked to left needle tip, k2togtbl] to end. Cut yarn leaving a 9" (23 cm) tail, and pull tail through rem st.

FINISHING

Weave in ends but do not trim. Soak in cool water until fully saturated (about 30 minutes). Press to remove water, roll in a towel, and blot to remove extra water.

Block to measurements as shown on schematic, pinning out each "point" at larger beads to form scalloped edge. Allow to dry completely. Shawl will relax to finished measurements after removing pins. Trim ends.

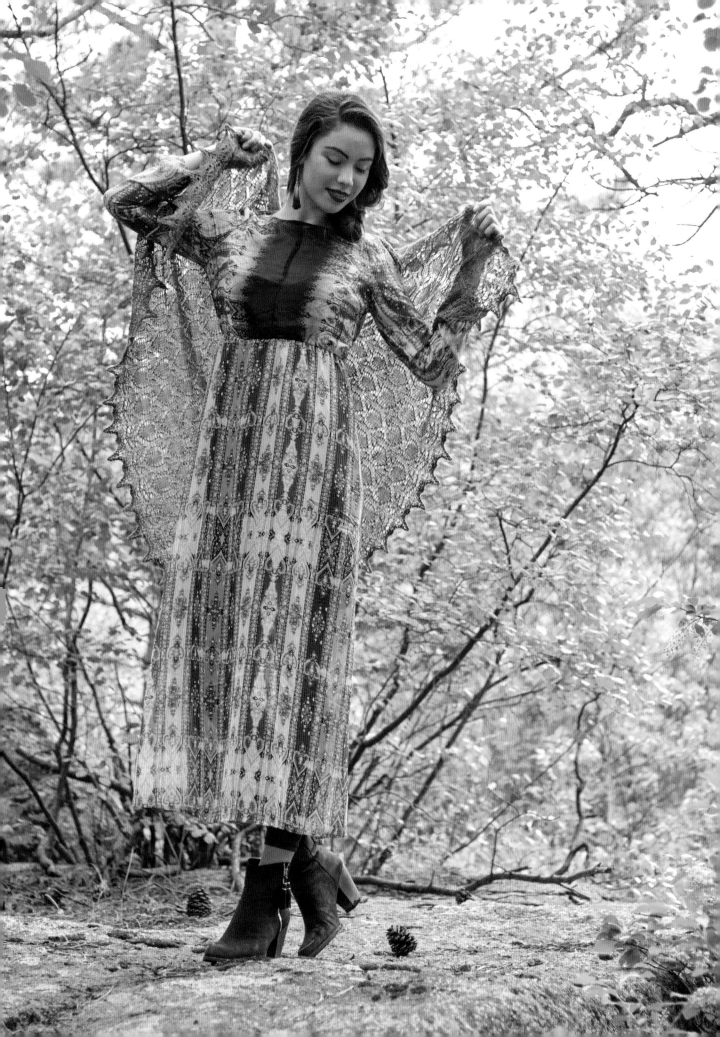

knit

· purl

k1tbl

o yo

／ k2tog

＼ ssk

Λ s2kp (see Techniques)

k1f&b (see Techniques)

[(k1, yo) twice, k1] in same st

cluster (see Stitch Guide)

M make 1 by lifing horizontal bar from row below and knit without twisting

place larger bead (see Techniques)

s2kp and place peacock bead (see Techniques)

no stitch

pattern repeat

55"
139.5 cm

31"
78.5 cm

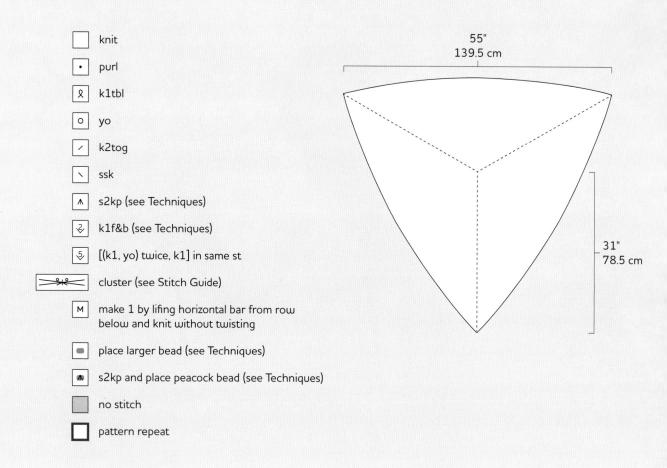

Chart A

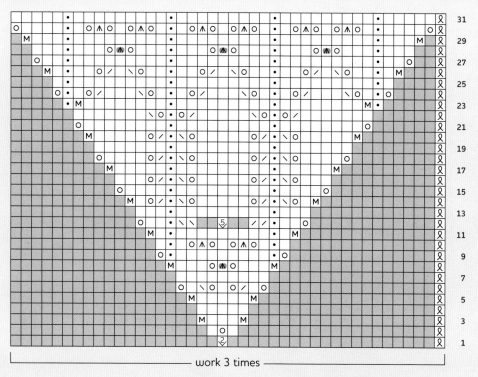

work 3 times

Chart B

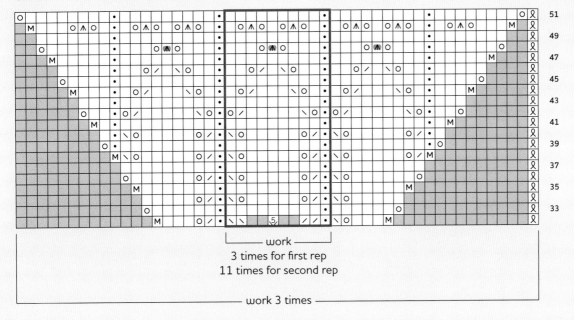

work
3 times for first rep
11 times for second rep

work 3 times

Chart C

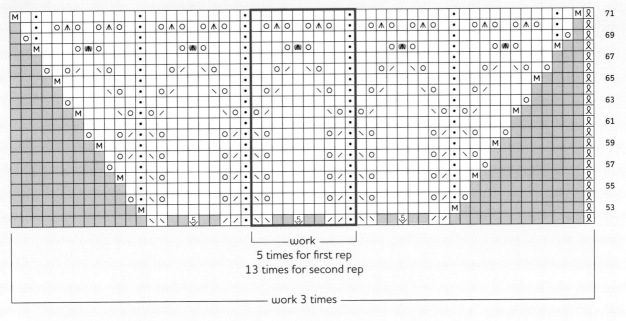

work
5 times for first rep
13 times for second rep

work 3 times

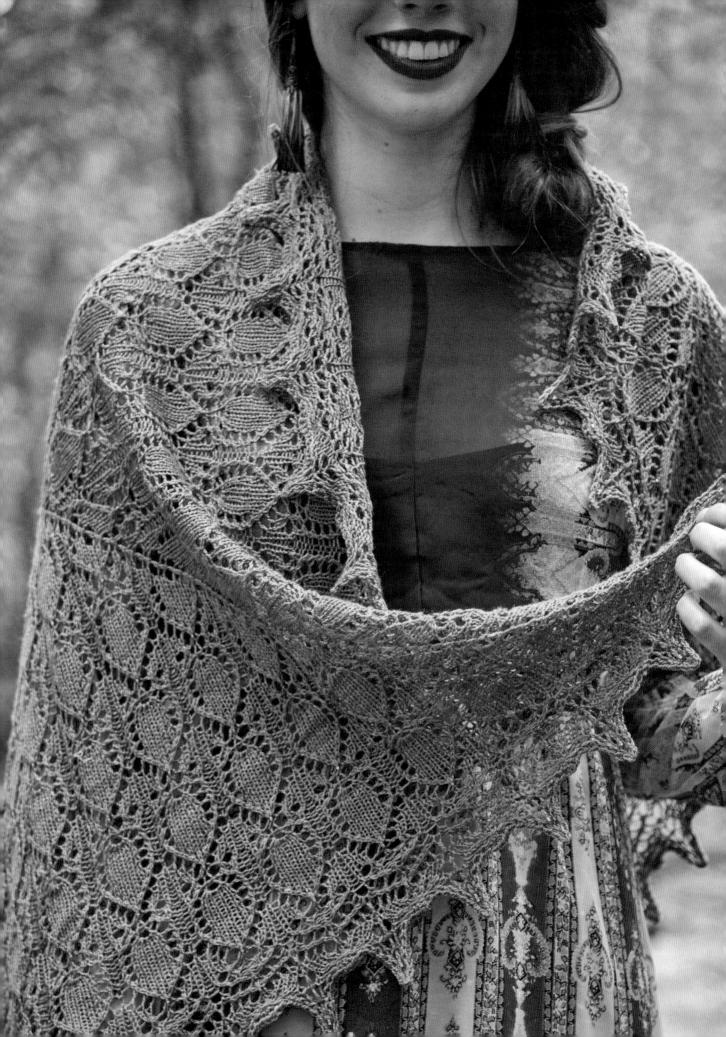

Chart D

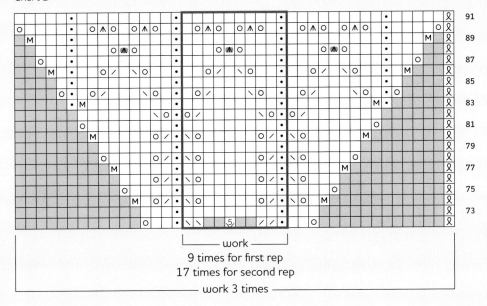

├─ work ─┤
9 times for first rep
17 times for second rep
├──── work 3 times ────┤

Chart E

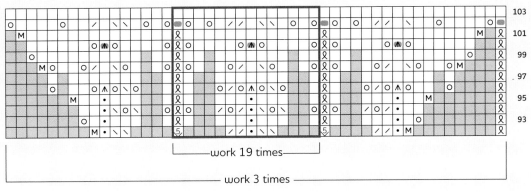

├──work 19 times──┤
├──── work 3 times ────┤

Chart F

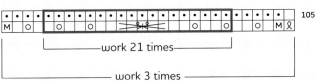

├──work 21 times──┤
├──── work 3 times ────┤

SOURCES FOR SUPPLIES

YARN

Alchemy Yarns of Transformation
alchemyyarns.com

Cascade Yarns
cascadeyarns.com

Crystal Palace Yarns
straw.com

The Fibre Company
thefibreco.com

Freia
freiafibers.com

Jade Sapphire
jadesapphire.com

Madelinetosh
madelinetosh.com

Malabrigo Yarn
malabrigoyarn.com

Miss Babs
missbabs.com

Quince & Co.
quinceandco.com

SweetGeorgia
sweetgeorgiayarns.com

Tess' Designer Yarns
tessyarns.com

A Verb for Keeping Warm
averbforkeepingwarm.com

BEADS

Artbeads
artbeads.com

Caravan Beads
caravanbeads.net

Fusion Beads
fusionbeads.com

TOOLS

ChiaoGoo
chiaogoo.com

HiyaHiya
hiyahiyanorthamerica.com

Lacis
lacis.com

Skacel/Addi
skacelknitting.com/addi-Needles-and-Accessories

Bead Finishes

Finish Name	Description	Effect
Color-lined	lined with a colored coating	Inner color glows
Metal-lined	lined with a metallic coating, often silver or gilt (gold)	Nice sparkle
AB (Aurora Borealis)	an iridescent surface finish; can also be lined	Reflects a rainbow along with base color
Iris	similar to AB with assorted hues	Reflects a rainbow along with base color
Rainbow	similar to AB	Reflects a rainbow along with base color
Luster	shiny finish that is slightly pearl-like	Extra glow
Gold Luster	shiny finish with a metallic/golden glow	Warm, metallic glow
Ceylon	opaque, solid pearl-like finish	More glow than plain opaque beads
Opaque	opaque, solid color	Reads as solid color
Transparent	allows color to show through	Glows more than solid color and allows yarn color to show
Matte	dull finish	Recedes into the background
Lined Matte	matte translucent bead with metallic lining	Glows delicately; subtle
Permanent Galvanized	metallic plated	Sparkles
Opal	semi-translucent usually with metallic lining	Warm glow
Alabaster	similar to opal, also often with lining	Warm glow

New Heights in Lace Knitting Copyright © 2016 by Andrea Jurgrau. Manufactured in China. All rights reserved. No part of this book may be reproduced in any form or by any electronic or mechanical means including information storage and retrieval systems without permission in writing from the publisher, except by a reviewer who may quote brief passages in a review. Published by Interweave Books, an imprint of F+W Media, 10151 Carver Road, Suite 200, Blue Ash, Ohio 45242. (800) 289-0963. First Edition.
www.fwcommunity.com

a content + ecommerce company

19 18 17 16 5 4 3 2 1

Distributed in Canada by Fraser Direct
100 Armstrong Avenue
Georgetown, ON, Canada L7G 5S4
Tel: (905) 877-4411

Distributed in the U.K. and Europe by F&W MEDIA INTERNATIONAL
Brunel House, Newton Abbot, Devon, TQ12 4PU, England
Tel: (+44) 1626 323200, Fax: (+44) 1626 323319
E-mail: enquiries@fwmedia.com

Distributed in Australia by Capricorn Link
P.O. Box 704, S. Windsor NSW, 2756 Australia
Tel: (02) 4560 1600, Fax: (02) 4577 5288
E-mail: books@capricornlink.com.au

SRN: 16KN07
ISBN-13: 978-1-63250-231-5

Editor: Erica Smith
Technical Editor: Therese Chynoweth
Art Director: Elisabeth Lariviere
Design and layout: Nicola DosSantos
Photographer: Donald Scott (except where noted)
Stylist: Tina Gill
Hair/Makeup: Kathy Mackay

Taken on Mount Whitney by J. A. Voulgaris

ABOUT THE AUTHOR

Andrea Jurgrau is a nurse practitioner and avid lace knitter, as well as author of *New Vintage Lace* (Interweave). Her patterns have appeared in *KnitScene, Vogue Knitting, Spin-Off, Knit Red, One + One Scarves, Shawls & Shrugs, Enchanted Knits,* and *The Unofficial Downton Abbey Knitting Collection.* She resides in New York.

Metric Conversion Chart		
To Convert:	To:	Multiply By:
Inches	Centimeters	2.54
Centimeters	Inches	0.4
Feet	Centimeters	30.5
Centimeters	Feet	0.03
Yards	Meters	0.9
Meters	Yards	1.1

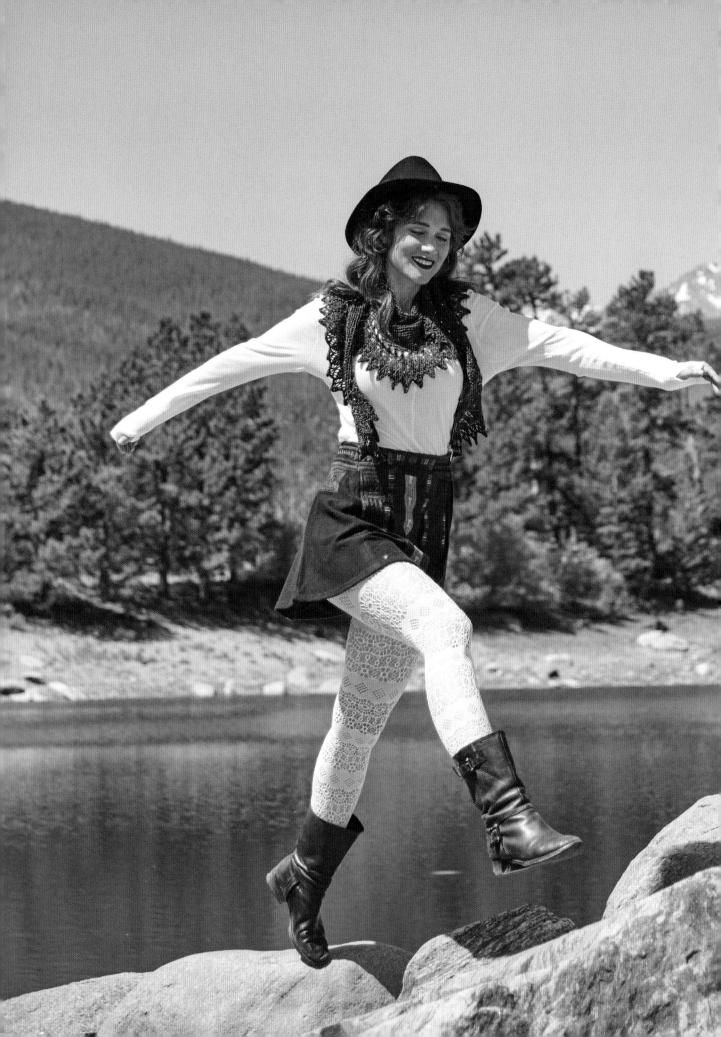

GRATITUDE

I would like to thank my husband, John, and daughter, Hallie, for their continued patience and support, and for tolerating even more yarn all over the house. And to Hallie, who has been my beautiful model for so long, try as she might to escape that role. I thank my test knitting "posse" for continuing to believe in me; every piece in this book was test knit at least three times, thanks to Cara Baustian, Dawn Gayer, Mary Rose, Sue Elkind, Amanda Wyngaard, and Sheila Macomber. Thanks to Margaret Carroll, who continues to step in as my business consultant. I want to thank Sandra Burkett again, for her support over many years, and for the great face shot. I thank Allison Korleski and Kerry Bogert for once again giving me this opportunity and Erica Smith and the entire team at Interweave for their hard work to make this book happen. I thank my Thursday evening knitting group for fiber friendships that have been long lasting. I also thank the following yarn companies: Jane and Ken at Jade Sapphire, for not only yarn but also encouragement and friendship; Crystal Palace, Malabrigo, SweetGeorgia, The Fibre Company, Freia, A Verb for Keeping Warm, Quince & Co., and Miss Babs for their generous yarn support. Finally, I thank my new feline muse and blocking companion, Chai Latte; please do not chew on my yarn, dude.

A note about the samples in this book: All samples were knit by the author except the Persian Sunrise samples, which were knit by Dawn Gayer. Thank you so much!

DEDICATION

This book is dedicated to the memory of Lucy Voulgaris, my mother-in-law, who loved hiking and backpacking and shared that love with her children. In turn, my husband, John, shared that love with me.

INDEX

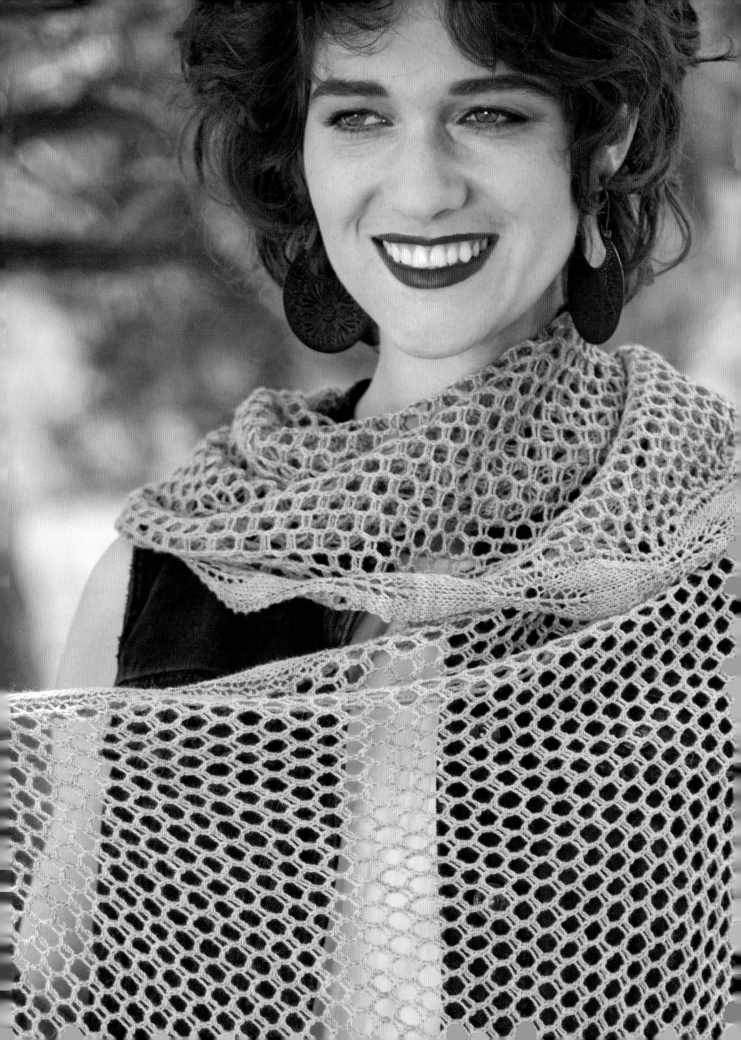

Lovely Lace Knitting,

Thanks to These Resources from Interweave

New Vintage Lace
*Knits Inspired
by the Past*

Andrea Jurgrau

9781620331002 | $24.99

Wrapped in Lace
*Knitted Heirloom Designs
from Around the World*

Margaret Stove

9781596682276 | $26.95

Knitted Lace of Estonia
*Techniques, Patterns and
Traditions with DVD*

Nancy Bush

9781596683150 | $26.99

Available at your favorite retailer or Shop.knittingdaily.com

Join Knittingdaily.com, an online community
that shares your passion for knitting. You'll get
a free eNewsletter, free patterns, a projects
store, a daily blog, event updates, galleries,
tips and techniques, and more. Sign up at
Knittingdaily.com.

From cover to cover, *Interweave Knits*
magazine presents great projects for the
beginner to the advanced knitter. Every issue
is packed full of captivating, smart designs,
step-by-step instructions, easy-to–understand
illustrations, plus well-written, lively articles
sure to inspire. **InterweaveKnits.com**